Rustic
Accents
for your
Home

Rustic Accents
for your
Home

45 *Projects from*

& *Vines, Twigs*

Branches

Laura Donnelly Bethmann and Ann Ramp Fox

Photography by Giles Prett
Illustrations by Laura Donnelly Bethmann

Storey Books
Schoolhouse Road
Pownal, Vermont 05261

*The mission of Storey Communications
is to serve our customers by publishing practical information
that encourages personal independence in harmony with the environment.*

Edited by Deborah Balmuth and Nancy Ringer
Cover design by Meredith Maker
Text design and photostyling by Carol Jessop, Black Trout Design
Text production by Susan Bernier
Cover and interior photographs by Giles Prett
Indexed by Susan Olason, Indexes & Knowledge Maps

Printed in Hong Kong by Regent Publishing Services
10 9 8 7 6 5 4 3 2 1

Library of Congress Cataloging-in-Publication Data

Bethmann, Laura Donnelly, 1953–
 Rustic accents for your home : 45 projects from vines, twigs & branches /
Laura Donnelly Bethmann and Ann Ramp Fox.
 p. cm. — (The rustic home series)
 ISBN 1-58017-135-4 (hc. : alk. paper)
 1. Nature craft. 2. Decoration and ornament, Rustic. 3. Twigs. 4. House
furnishings. I. Fox, Ann Ramp, 1945– . II. Title. III. Series.
 TT873.B48 1999
 745.51—dc21 99-27368
 CIP

DEDICATION

To my husband, Bill, for sharing my daily wanderings and discoveries;
to my three beautiful daughters
Jeanne, Jill, and Marjorie for their encouragement;
and to my parents for instilling in me this reverence for Nature.

— Ann Ramp Fox

For Chris, Kate, Cara, and to living the twig life.

— Laura Donnelly Bethmann

ACKNOWLEDGMENTS

We thank each other for our hard work and mutual support. Our thanks to Chris Bethmann for lending his expertise and valuable suggestions regarding tools, trees, and project names. Thanks to Lori Halsey for her twigological outlook. A big hug for Cara, Kate, and Jess for their notions and comments about twigs.

We could not have written this book without the help of our editors, Deborah Balmuth and Nancy Ringer, who focused and organized our efforts. Thank you to the whole team at Storey for your excellent work. And to our inspiration, Mother Nature.

CONTENTS

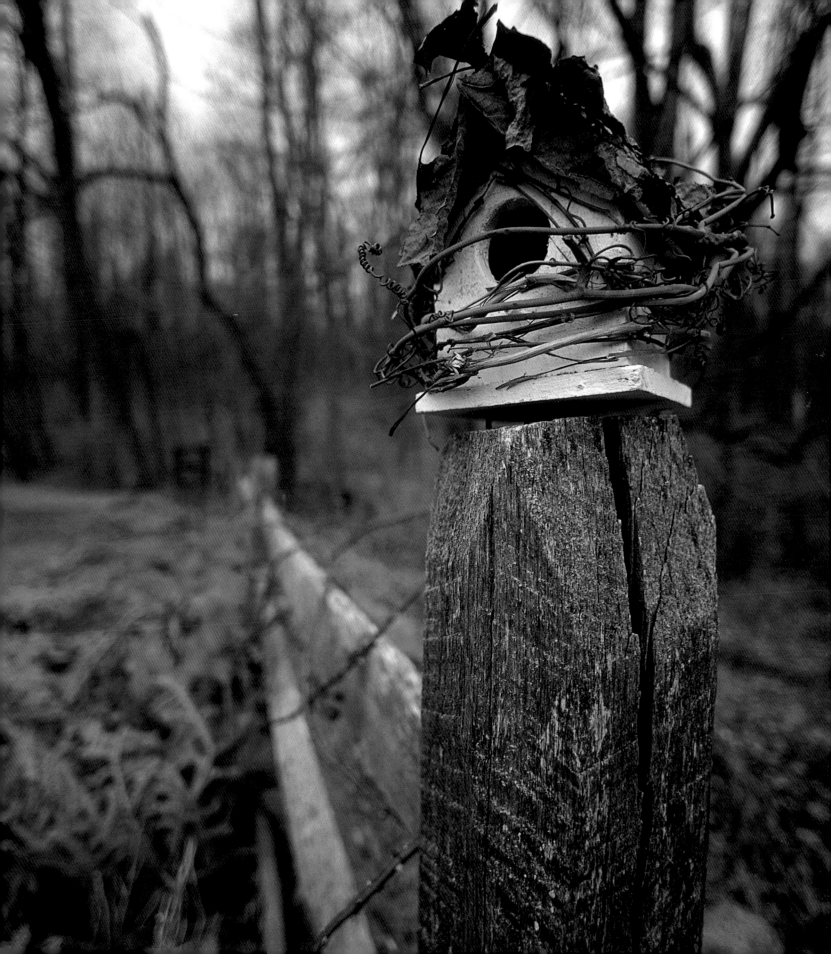

INTO THE WOODS

The change was extraordinary. Over twenty years ago, my husband, Chris, and I moved to a little town tucked between Barnegat Bay and the Pine Barren woods of southern New Jersey. Though we had traveled only 60 miles from our former home, it seemed as if we had arrived at some faraway land.

The Pine Barrens, John McPhee's celebrated book, tells the fascinating story of this compelling place, and echoes my initial feelings: "A visitor who stays awhile in the Pine Barrens soon feels that he is in another country." Encompassing over 2,000 square miles, the Pine Barrens is almost completely undeveloped forest and was the first designated International Biosphere Reserve in the United States. Crotchety pitch pine stretches for miles in the pigmy forest, named so for the trees that grow no taller than five feet. Almost every year ravaging forest fires burn thousands of flat, sandy acres and the plants that thrive have adapted to this frequent devastation.

Nevertheless, there's a quiet magic in these woods. Cedar, oak, maple, holly, sweet bay magnolia, laurel, huckleberry, and especially pines dominate the landscape. But the enigmatically beautiful rivers and cedar swamps are my favorite places. As McPhee writes, "The characteristic color of the water in the streams is the color of tea — a phenomenon often called 'cedar water.'. . . Cedar trees combine with iron from the groundwater to give the rivers a deep color. In summer, the cedar water is ordinarily so dark that the riverbeds are obscured, and while drifting along one has a feeling of being afloat on a river of fast-moving potable ink."

Every time I venture into the Pine Barrens, I am captivated by the strange allure and unspoken knowledge it holds. Over the years, Ann and I have created many paintings, drawings, and nature prints of the botanical subjects and woodland sites we've found, as well as functional and decorative home accessories with branches, twigs, and vines collected from my small yard and Ann's 130 acres in the woods.

The natural world is our home, and we like to bring a little bit of it into the house, In *Gift from the Sea*, Anne Morrow Lindbergh's love of nature is evident as she describes a solitary visit to a remote island. She stayed in a sparsely furnished beach cottage adorned only by "the wind, the sun, the smell of the pines blow[ing] through its bareness." Lindbergh welcomed the simplicity of her temporary retreat but began to feel enclosed by the blank walls. "I dragged home from the beach gray arms of driftwood, worn satin-smooth by wind and sand. I gathered trailing green vines with floppy red-tipped leaves. I picked up the whitened skeletons of conch shells, their curious hollowed-out shapes faintly reminiscent of abstract sculpture. With these tacked to walls and propped up in corners, I am satisfied."

— *from Laura*

Just as all children have a fascination for nature, so did my five sisters and I. We spent many happy hours exploring the fields and woods and the cedar swamp of our 40-acre property in southern New Jersey. Being allowed this freedom by our mother and father, who thought it a great learning experience, we fell under the spell of this area known as the Pine Barrens. Fortunately for us, our parents never insisted we not bring into the house our treasures of fallen-down birds' nests, odd-looking rocks, and deceased insects to identify. Our simple drawings of birds and wildflowers were always proudly displayed. In this way we were encouraged to observe and learn, to appreciate and respect the world around us.

Having been farmers all their lives, my father's people were very much attuned to the weather, animals, plants, and insects in this area. Years of observing all these aspects of nature gave my father a wonderful store of information, which he generously shared with us. My mother, who had grown up in a city, was enthralled by the variety of birds and wildflowers found here. My grandmother, H. Ann Lowe, and my aunt, Helen Zimmer, also helped instill in us a love of the wildflowers and birds surrounding our home. Through sharing their knowledge and concerns, they imparted to us a great respect for nature.

The Native Americans who inhabited this land before the would-be farmers of Europe arrived understood and respected their dependence on the world of nature. They referred to the winds and the trees and the animals as their brothers, taking with utmost gratitude only what they needed for food, clothing, and shelter. It would greatly benefit our world if we could learn to be as appreciative and sensitive to the earth as the Native Americans.

My husband, Bill, and I live on 130 acres in the Pine Barrens. We operate a 20-acre cranberry bog that is about 100 years old. We feel extremely fortunate to live in such a beautiful spot. We believe we are stewards of the land. It was here before us and will be here after us, and it should be left at least as good as we found it.

Like all farmers, our lives are marked by the seasons. There is *always* work to be done, but we invariably find time for a walk to check on whether the lady's slippers are blooming, to see if any turtles have laid their eggs in the sandy banks, or to see if the long-eared owl has returned to her old nesting spot.

My life has been so enriched by the interest in nature instilled in me as a child. It has affected in a good way all the areas of my life.

— *from Ann*

I went into the woods to live deliberately, to front the essential facts of life, and see if I could not learn what they had to teach, and not when I came to die, discover I had never lived.

—Henry David Thoreau,
Walden

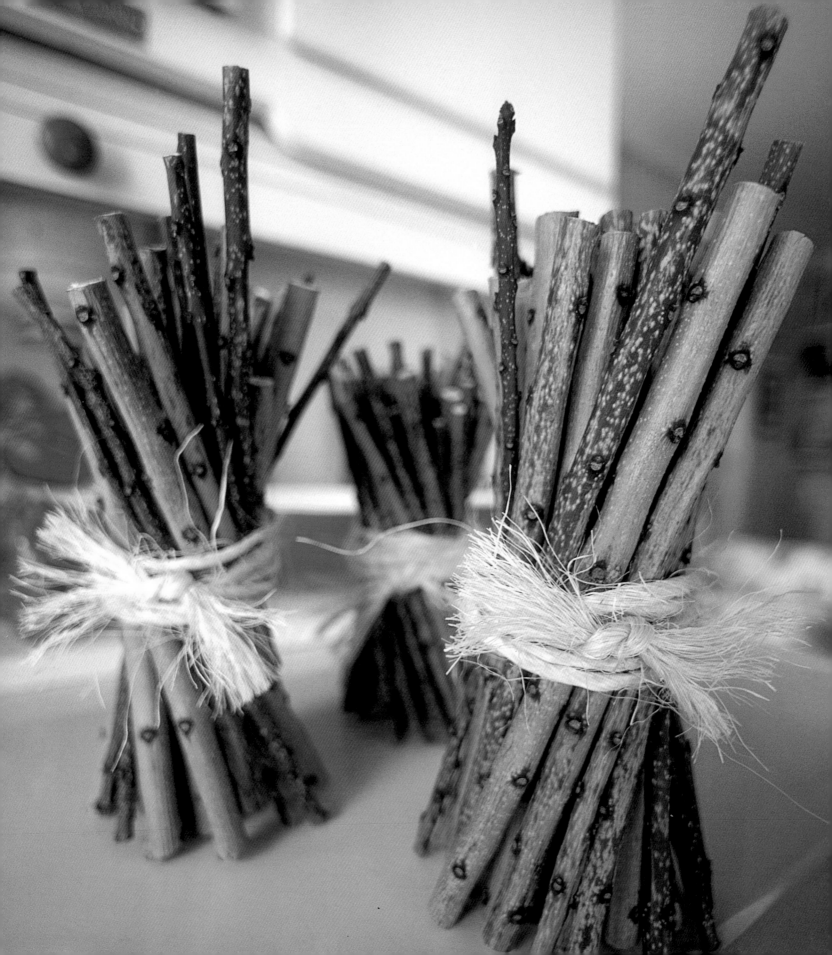

The Art and Craft of Working from
Nature's Storehouse

TWIGOLOGY

Many of the projects in this book, fondly nicknamed "twig things," have evolved in the course of writing. Some designs have simply improved and others became something completely different. Our goal was to design twig things for every room in the house. We kept some ideas, discarded others, and in the end chose the projects we liked best.

As we planned and constructed our twig things, branches, twigs, and vines invaded our homes. They were in the studio, on the porch, the kitchen floor, the front entry, stairway landings, and in the car. And when we weren't making twig things, we were out gathering more twigs.

Our friends and relatives couldn't grasp the significance of this. Our children referred to our endeavors as "playing with twigs all day." Well, of course, they were right. We liked taking walks in the woods and making things. To assist us in defining our task, our friend Lori Halsey casually coined the term *twigology*.

The *Oxford English Dictionary* devotes more than an entire page to the subject of twigs, but *twigology* is not mentioned. We created our own definition:

Twigology is the art of forming whimsical, practical, naturally pleasing twig things while enhancing one's knowledge of the unique characteristics and beneficial qualities of trees.

So, as we create useful, fun things for our homes, we also learn more about the natural world. When searching a woodland for vines and branches, claiming some for making twig things, it doesn't hurt to thank the trees. They grow nearly everywhere on earth and are perhaps the biological entity most taken for granted. Trees provide natural air conditioning, wind breaks, and homes to animals and insects, and prevent soil

erosion. As the first natural resource used for fuel, shelter, spears, and boats, trees were essential to early human development. We continue to use trees for these and countless other purposes, such as for making medicines, paper, and musical instruments. They are a renewable resource, but must be carefully harvested and allowed to regenerate.

Soon, you will be gathering tools and twigs to create some inviting and artful home projects. While you are hard at work, some inquisitive person will want to know just what you are doing. Please remember, while describing your fascination with the natural world and enjoyment in home decorating, to use the term *twigology!*

BRANCHING OUT

The particular trees, shrubs, and vines we used are named in each project description. We chose from what is abundantly available in our area just as your choices will be based on what is available to you. If you have no ready source for materials, such as your own or a friend's backyard, locate nearby woodlands or undeveloped lots. You can find property owners through town, county, or city records and ask permission to prune or cut the saplings, branches, and vines needed.

You may be able to get others to cut your branches for you. Trees are generally pruned in spring and fall. Look for pruned branches stacked for removal near tree-planted properties. Get information about clean-up programs on school grounds or county, state, and federal parks, which are pruned and cleared from time to time. Contact the superintendent or manager with your request. Local farms, nurseries, zoos, and botanical gardens; professional landscapers, gardeners, and tree service and brush removal companies; and local or county road departments are good sources of pruned limbs and may let you take what you want.

Bring along the correct tools (see Tools and Supplies on page 4), including a measuring tape for cutting the appropriate lengths and checking for appropriate diameter. Make initial cuts a little larger than required, then cut to length at home while constructing the project. Remember, natural materials

These entertainments
are medicinal.
They sober and heal us.
These are plain pleasures
kindly and native to us.

— Ralph Waldo Emerson,
Nature

Grasp together the cut ends of large branches and saplings for toting home or to your car. When gathering many small twigs, carry a large basket or bag. Collect vines by coiling, as you would a garden hose.

are nonconforming, and perfect symmetry is impossible to achieve. No two branches are ever exactly alike, but that's just what we like about them. Expect and enjoy the variations of natural materials. Let the personality and vitality of the materials tell you which twigs to choose. If one twig doesn't want to conform to the spot you have chosen for it, pick another. That first twig is probably destined for a different project!

Get the Facts

To identify the trees and plants you are working with, buy field guides or borrow them from the library. Useful guides will include photos of leaf, bark, flower, and fruit, and even a view of the entire tree or plant, showing overall shape and appearance with and without leaves (for the deciduous varieties). The introduction should state how to use the book, explain the different plant parts, and show how to identify them using an identification key. Field guides of wild plants are especially helpful for identifying poisonous ones! Look up poison oak, poison ivy, and poison sumac in your field guide, see what they look like, then *avoid them!*

When walking through wooded areas, wear appropriate footwear. Keep away from briars and any thorny undergrowth. Be careful not to step on or injure endangered or threatened plants, and certainly don't collect them. A list of these plants in your area can be obtained from local public gardens, conservation groups, or your state department of natural resources. Look them up in your field guides so that you'll be able to identify them in the wild.

Critter Considerations

Before cutting into trees and shrubbery, check that you are not about to disturb any nesting birds, animals, bees, or wasps. Woodland animals, including snakes, generally want to avoid confrontations. When we meet up with a snake, we head in the opposite direction and the snake is happy to do the same.

Bugs are more likely to be invited in on fresh-cut garden flowers than on the tree limbs you bring home if you do the following bug check: Before cutting branches, twigs, and vines, look for crawling insects, fungus growth, communities of tiny holes or nests, and damaged or loose areas of bark. If you find no evidence of bugs or fungus, go ahead and cut the limbs. But, if seeing isn't believing and you're still concerned about bugs, here are three precautions for destroying or removing *potential* insects before using your natural materials. Choose one and follow product cautions.

- Secure in black plastic bags with mothballs for one week
- Wash with mild solution of bleach and water, rinse well, and let dry
- Spray or brush with one or two coats of polyurethane to seal

Wood Words

To clarify our terms, here's what we mean by the following words:

Vines: Woody stems of climbing plants such as grapevine, wisteria, honeysuckle

Twigs: Narrow limbs extending from tree branches and shrubs

Branches: Larger limbs extending from tree trunks

Saplings: Trunks of young trees, 1 to 2½ inches (2.5 to 6.3 cm) in diameter

Limbs: Used as a general term to include all or any of the above

Stay Sharp

Cutting tools work best when kept dry, sharp, clean, and lubricated. Sharpen shears with a file or sharpening stone with the following motion: File toward the cutting edge, moving the file from the V of the open shears up and toward the blade tip. Repeat four or five times on each blade (unless shears have a blade on only one side). If sharpening with a small sharpening stone, use the same motions, but add a few drops of machine oil. To clean and lubricate shears, rub a few drops of oil in with a soft cloth.

Hold shears firmly in place with blades off the edge of the tabletop.

TOOLS AND SUPPLIES

Our carpentry skills are, well, nonexistent. But with simple hand tools and simple construction techniques we managed very well after a little practice. If your skills are limited, the rest of this chapter is devoted to you. We describe what tools to use, followed by an explanation of even the simplest building techniques.

Tools

Depending on the project, you may also find work gloves, safety glasses, waist or pocket apron, pocketknife, T-square, awl, chisel, pencil, and scissors helpful.

One-Handed Pruning Shears. Short-handled shears; either anvil blades (straight) or hooked blades (curved). Use for cutting twigs and branches up to ½ inch (1.3 cm) in diameter.

Two-Handed Lopping Shears. Long-handled, two-bladed shears. Use for reaching high branches and vines. Long handles provide greater leverage than pruning shears to cut through branches and saplings up to 1½ inches (3.8 cm) in diameter.

Small Handsaw. The blade should be 20 inches (50 cm) long, with 8 points per inch. Use for cutting and trimming branches and saplings that are too thick for shears.

Tape Measure. Eight-foot (2.4 m) length (at least), retractable. Use for measuring limbs before cutting and during construction.

Side-Cutting Pliers. Combination wire cutter and pliers. Use for cutting and twisting wire.

Tack Hammer. Light-duty hammer. Use for driving nails into vines, twigs, and small branches.

Claw Hammer. A medium-duty hammer. Use for driving nails into larger branches and saplings. Also good for pulling out nails.

Utility Knife. A knife with a retractable blade. Use for cutting cardboard, small twigs, and bark. Replace the blade as necessary.

Glue Gun. Melts sticks of glue with heat. Useful for immediate bonding.

Supplies

You can find these supplies in hardware stores and craft shops. Keep them with your tools in a portable toolbox or handled basket, and they'll always be ready when you are.

Nails. Steel wire nails with small, flat heads. They're available in many different sizes — use the size called for in each project.

Wire. Made from copper or steel. Use 18-gauge wire for binding large limbs, and thinner 24-gauge wire for small limbs.

Glue. Yellow wood glue, or a thick resin glue formulated for wood. Read label directions and precautions.

Glue Sticks. For use with glue gun.

Spray Adhesive. For use with paper. Repositionable adhesive is easier to work with. Take note of label precautions.

Twine. Available in light-duty and heavy-duty weights. Use for decorative binding and wrapping.

Raffia. Available in bundles of different colors. Check craft supply stores. Use for decorative binding.

TWIG TECHNIQUES

There are seven twig techniques basic to all of the projects: cutting, bending, notching, gluing, nailing, binding, and finishing. This section defines each technique, describes the use of tools and supplies, and offers how-to explanations and tips.

The specific twig techniques used to construct each project are noted at the beginning of every project description. Refer back to this section for detailed information as needed.

Cutting

Whether gathering materials from the wild or constructing your project at home, most of the projects in this book require some cutting.

Small twigs and vines. Use one-handed pruning shears to cut vines and twigs up to ½ inch (1.3 cm) in diameter by squeezing handles together.

Small branches and saplings. Two-handed lopping shears have long handles for greater leverage when cutting up to 1½-inch-thick (3.8 cm) branches or saplings. Grasp wood between open blades and force handles together.

Thick branches and saplings. Use a small handsaw to cut branches and saplings that are too large for shears. Support the limb from underneath by placing it on two sawhorses, on the edge of a table, or just raised up off the ground to a comfortable height for working. (Ann likes to use the tailgate on the back of her pickup truck.) Place the blade perpendicular to the limb, and begin a back-and-forth sawing motion until the saw cuts through. If the limb breaks off before sawing is complete, trim the rough edge with pruning shears.

Cutting Tips

■ When gathering, measure the length needed and cut somewhat beyond that point. Trim the wood to size during project construction.

■ When cutting limbs, leave the branching twigs intact. Many projects require twiggy embellishment. Twigs that are too long or undesired can be trimmed during project construction or after completion.

■ If your shears have a safety latch, keep it hooked when not in use.

■ Wear safety glasses and work gloves.

■ When cutting an overhead limb, have an assistant hold the limb and pull it away from you as it falls from the trunk.

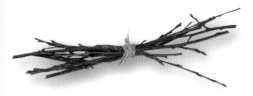

Cutting side branches. To cut a side branch off a tree trunk, undercut the branch first: Hold the handsaw upside down and make a cut on the underside of the branch. This cut should be about ½ inch (1.3 cm) deep or until limb begins to pinch the saw. Remove the saw. Cut through the top of the branch down to meet the undercut. This technique can also be used to cut larger limbs into smaller pieces.

Bending

Limbs and vines formed into arcs often create the basis for a project's design, such as the Twiggy Easel or Toothbrush Trellis. Bending limbs into a curved shape also adds decorative appeal, such as the Open Air Partition and Window Shutters.

Very flexible limbs and vines can easily be formed into the desired shape, and with the proper coaxing, even thick or less flexible limbs can be flexed into a curved position.

Twigs and small branches. Grasp the limb near each end and bend, forming an arc or circle.

Stronger limbs. For thick limbs, more coaxing may be needed. Place your hands a few inches apart on the section intended for bending. Gently flex and arch the wood. Repeat this procedure along the limb, a few inches at a time, adjusting the limb's curvature until you reach the desired effect.

Be gentle yet forceful to coax branches into shape.

Notching

Notches are cuts made into limbs where they cross and meet, allowing them to fit into one another, interlocking. Notched sections cut out of round limbs create a tight fit, aid glue adhesion, and keep the wood from slipping when nailing or binding it together.

Twigs and small branches. Place limbs in position for joining. Mark both edges of the joint on the bottom limb with a pencil. Remove the top twig. Use the tip of pruning shears or a utility knife to cut a **V**-shaped notch between the marks.

Use the tip of the pruning shears to notch small branches and twigs.

Large branches and saplings. Place limbs in position for joining. Mark the joint on the bottom limb with a pencil. Place a saw blade on one mark and saw about ¼ inch (.6 cm) into the branch. Repeat, sawing the other mark. Score the wood on both sides, drawing a pocket or utility knife across the branch from one cut to the other. Insert a chisel into each saw cut and pry out the wood.



Notching Tip

To smooth sawed notches, use a chisel to scrape along the grain of the wood, evening out the surface.



To notch larger branches, score between two sawed cuts with a knife, then chisel out the wood chip.

Gluing

Most projects requiring glue also use one other joining technique for stability, such as nailing or binding. Some projects combine all three techniques. Using glue sticks and a glue gun works well for some projects that involve lots of detailed glue-work, such as the log cabin dollhouse (see page 104).

How-to. Apply glue to contact areas, place glued sections together, and let dry undisturbed.

Choosing a glue. Use yellow wood glue unless resin glue is recommended. Resin glue is thick and sticky, so it bonds faster than wood glue, but it's also more toxic than wood glue.

Gluing Tips

■ Read all label instructions and precautions.

■ Allow the necessary drying time, usually 30 minutes, before resuming work on a glued section. Many projects are made a section at a time, allowing glue to dry in one section while you work on another section.

■ Small twigs, popsicle sticks, or cotton swabs make good applicators for applying glue.

Nailing

You can combine nailing with gluing or binding for stability. As wood dries it may shrink around the nail, tightening its grip. Or it may shrink away from the nail, opening up the hole. Most projects combine at least two joining techniques to ensure the project holds together over time.

How-to. Hold nail in place between thumb and forefinger. Hold hammer in other hand a few inches above the nail. Strike nail squarely on the nail head (not your thumb). Drive straight into the wood with each successive strike.

Removing nails. To remove a nail, wedge the claw end of the hammer under the nail head. Gently pull away, using the hammer head for leverage.

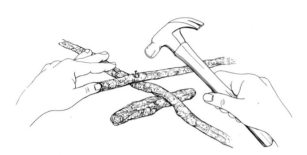

When hammering nails into a raised, curved section of limb, wedge a twig or branch underneath.

Binding with Wire

Both steel and copper wire are strong and decorative. Binding is usually combined with nailing or gluing for stability.

To make a crisscross twist. Beginning on the back side of your project, wrap a premeasured length of wire where the limbs cross, and bring the wire up to the front. Form an **X** by twisting the wire one-quarter turn, then wrap it around to the back side again. Twist the wire ends together once using your thumb and forefinger. Grasp the twisted ends with the tip of your side-cutting pliers and turn clockwise to further tighten the wire. Turn the pliers at least four to six rotations, or until the twigs are snug. If the wire is twisted too tightly, it will weaken and break. If this happens, remove the wire and begin with a new piece. Trim off the ends with the cutting edge of the pliers. Using the tip of the pliers, crimp the twisted, cut end and push it against the wood. This will secure the twisted wire and keep the sharp cut ends from sticking out.

Use pliers to tighten the wire binding before trimming off the ends.

Binding with Twine and Raffia

Twine and raffia are described here, but you may also want to try paper or fabric ribbon, or white or colored cording or piping for some projects.

How-to. Cut premeasured lengths of twine or raffia needed for the project. Make a crisscross twist as pictured below. For a double crisscross, do it twice. Instead of twisting at the back, as was done with wire, tie a square knot. Cut the remaining ends with a knife or scissors (A).

Three-way bind. To wrap a joint where three twigs come together, begin as if making a simple crisscross, but continue wrapping until every corner of the joint is covered. Knot the material at the back or underside of the project (B).

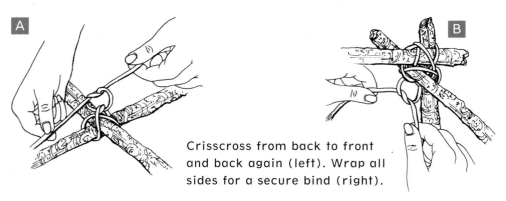

Crisscross from back to front and back again (left). Wrap all sides for a secure bind (right).

Binding Tips

- Wire lasts longer than twine or raffia.
- If you don't like the look of wire but the project requires a secure hold, you can wire your project, then wrap twine or raffia to cover the wire.
- Use the correct gauge wire, as noted in project instructions.
- Make sure all the crisscrosses are on the front or top of your project, and all the twisted ends are on the back or underside.

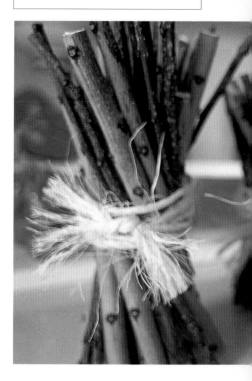

Finishing

All of the projects in this book can remain in their natural state, or they can be coated with paint or polyurethane.

Finishing with paint. Use any paint formulated for wood, such as acrylic craft paint, latex, or oil-based paint. Apply with a small paint brush, or use spray paint. Read all label directions before using.

Finishing with polyurethane. Polyurethane can be applied with a brush or sprayed from a can. It is available in both low and high gloss finishes. Read all label directions before using.

Finishing Tips

- Apply finish to your project after gluing and nailing. Binding should take place after applying the finish and letting it dry.
- If you are creating projects for the outdoors, make sure they will be at least partially sheltered, such as on a covered porch. Seal them with two or three coats of polyurethane or exterior house paint to help them withstand the outdoor elements.

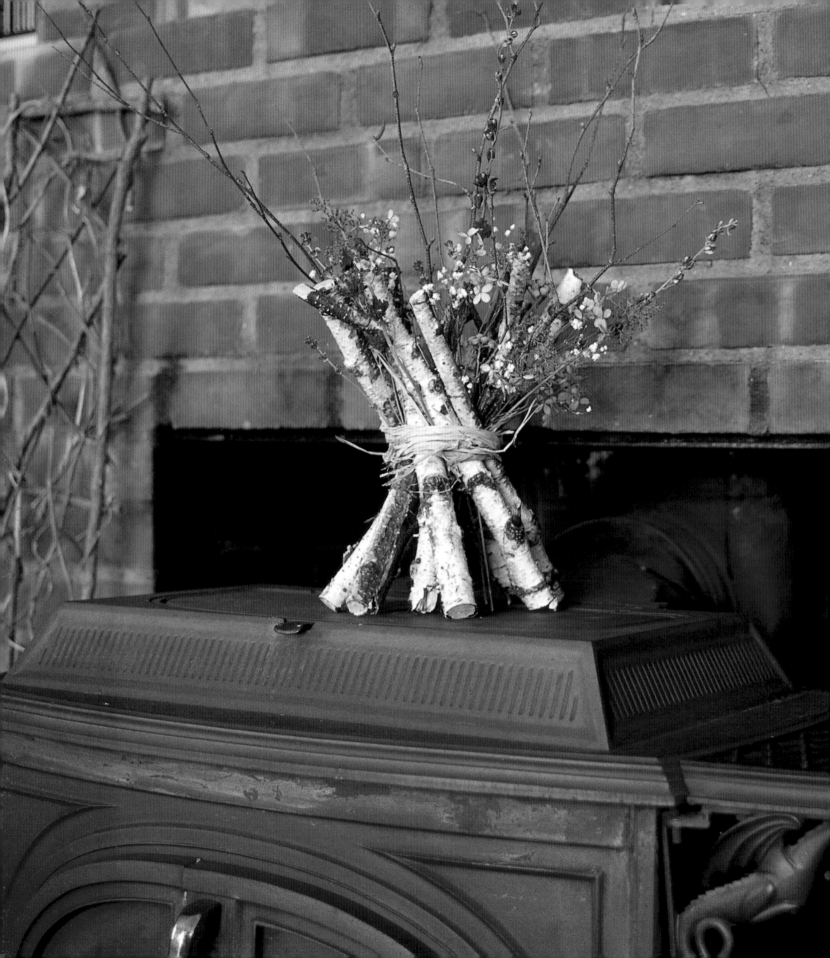

Rustic Adornments

GETTING
STARTED

Familiar and outdoorsy like a willow garden trellis or a bowery arbor, twig things bring nature into our homes. Starting out with one of the simpler projects will introduce you to the basics of working with twigs, especially if you aren't acquainted with the tools and techniques discussed in the last chapter. Twiggy bundles and bouquets (page 12) and rustic receptacles (page 27) are decorative objects requiring no construction. The potted-plant trellis (page 14) may be the easiest project in this chapter to make that involves some basic construction techniques. Another approach is to begin with the project you like most. Whether you want to add a few twig accents or many twig things to create a recurrent theme, your ensuing enthusiasm for favorite projects will inspire you.

All of the projects in this book are designed to complement one another. A study corner can be equipped with the desk set, twiggy easel, lampshade, and clock all tucked behind the open air partition. Enhance a kitchen window with venetian vines, a grouping of trellised container plants and trailing plants in potted-plant stands, and hang the herb tree drying rack nearby. The whimsical birch bark toilet paper roll cover, toothbrush trellis, baskets, twig mirror, towel and basket tree, and window screen can be fun and functional in the bathroom. Create your own twiggy environment by bringing nature home.

◀ Twiggy bundles are ideal for dressing up an unused woodstove during the summer months — just don't forget to remove them before starting a fire!

Twiggy Bundles and Bouquets

Twiggies, as we like to call them, are reminiscent of autumn leaves raked into neat piles on the grass, or cozy logs stacked on the fire grate waiting to be set aflame. Well-chosen, well-placed twig bundles and bouquets are textural, sometimes colorful, decorative accents. Choose the right size twigs to balance the space. Dominate the corner of a room with a large flowerpot filled with tall, twiggy branches. Tie simple bundles of twigs with twine, raffia, ribbon, or fabric to bedeck window ledges, table and shelf groupings, or just about anywhere. Spray paint them silver, gold, or a color that coordinates with the room. Arrange twigs in a crystal vase for a formal dining room or display a coffee can filled with twigs for a country kitchen. Twiggies can be rustic, jaunty, or elegant — whatever the surroundings require.

■ **Twiggy bundles.** Cut shapely twigs or branches, arrange them into a bundle, and tie with raffia, twine, or ribbon. For a free-standing bundle, trim the base evenly. If desired, spray paint the twigs, following the directions on the product's label.

■ **Twiggy bouquets.** Cut fine, feathery twigs or branches and arrange them in vases or containers. If desired, you can spray paint them, following the directions on the product's label.

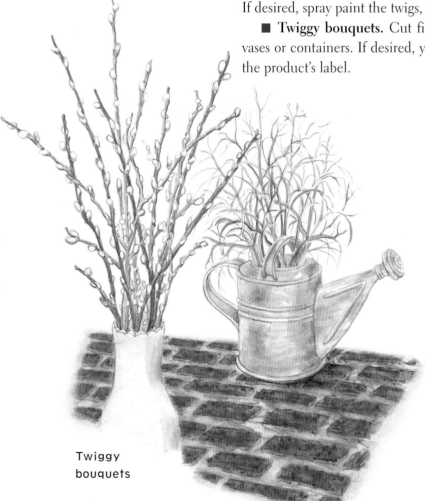

Twiggy bouquets

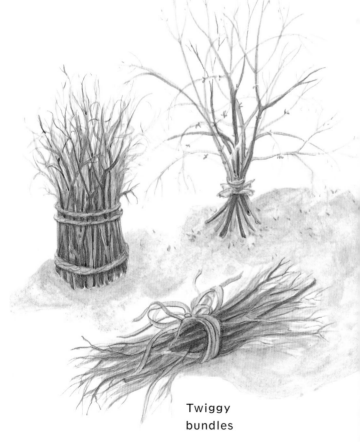

Twiggy bundles

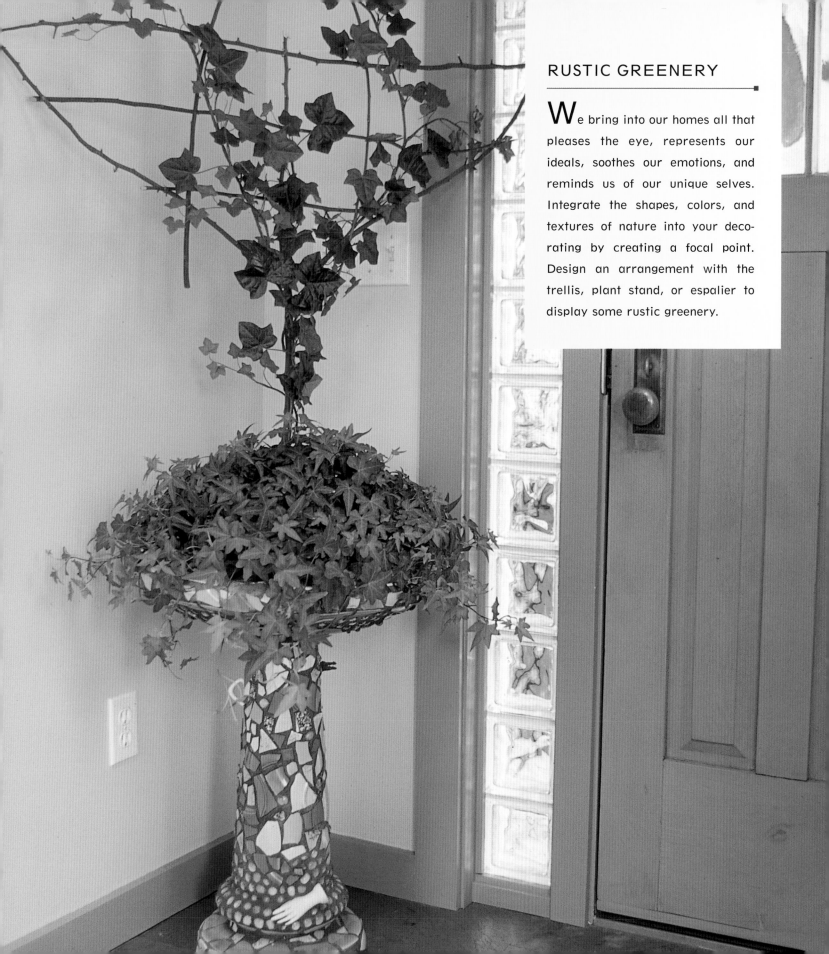

RUSTIC GREENERY

We bring into our homes all that pleases the eye, represents our ideals, soothes our emotions, and reminds us of our unique selves. Integrate the shapes, colors, and textures of nature into your decorating by creating a focal point. Design an arrangement with the trellis, plant stand, or espalier to display some rustic greenery.

Potted-Plant Trellis

Accommodate a climbing plant or create a natural background for any potted plant. A leggy scented geranium is supported by this trellis, which couldn't be easier to make. Crooked, forked twigs of Norway maple were chosen for the trellis, which is 24 inches (60 cm) high by 14 inches (35 cm) across its widest point. The height measurement allows for 10 inches (25 cm) to be inserted into the soil. Generally, the middle or top part of the trellis should be as wide or a little wider than the pot. This one was made for a 10-inch (25 cm) terra-cotta pot.

Make your own trellis designs by laying out lengths of twigs and arranging them in different crisscrossing patterns. You can use flexible twigs to create arches.

Materials

Seven twigs ½ inch
(1.3 cm) in diameter:
- 3 24"(60 cm), forked at one end
- 1 8" (20 cm)
- 1 10" (25 cm)
- 1 12" (30 cm)
- 1 14" (35 cm)

Twenty-four gauge wire
Four ¾- or 1-inch (1.9 or
2.5 cm) nails
Twine (optional)

Tools

Pruning shears
Side-cutting pliers
Tack hammer

Twig Techniques

Cutting
Binding
Nailing

1. Lay the three 24-inch (60 cm) twigs in the pattern shown (if one is a little longer than the others, use it in the center). Cut the bottom ends of the twigs at angles to form points. Bind the ends together at the base with a 10-inch (25 cm) piece of wire.

2. Lay the remaining twigs in place: The 12-inch (30 cm) twig across the top of the 3 bound long twigs, followed by the 14-inch (35 cm), the 10-inch (25 cm), and lastly the 8-inch (20 cm) twigs, each spaced about 3 to 4 inches (7.5 to 10 cm) apart. Center each one and nail in place. Bind the twelve intersection points with wire or twine.

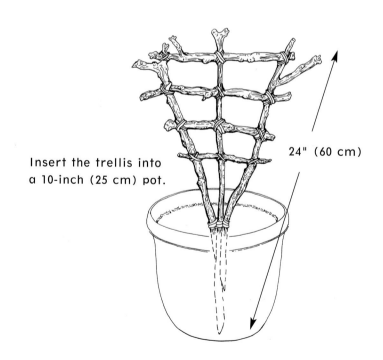

Insert the trellis into a 10-inch (25 cm) pot.

24" (60 cm)

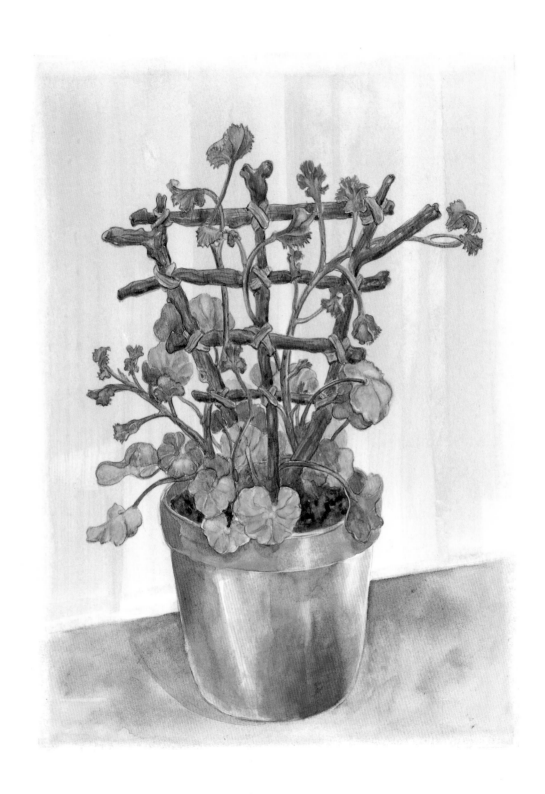

Potted-Plant Stand

Sturdy, branching twigs create this multilegged plant stand designed to hold a 4-inch (10 cm) pot. We used sassafras twigs; the finished height was fourteen inches (35 cm). The secret to this project is that only four of the legs, one from each twig, is needed to support the plant stand. All others are trimmed a little shorter so you don't go crazy trying to trim all the legs to exactly the same length.

Raffia keeps the corners tightly bound. Each of the eight corners consists of a three-twig intersection, which makes nailing difficult. Though wire won't easily conform to this configuration, initially it holds the structure together so the hands are free to make a tight bind with the raffia.

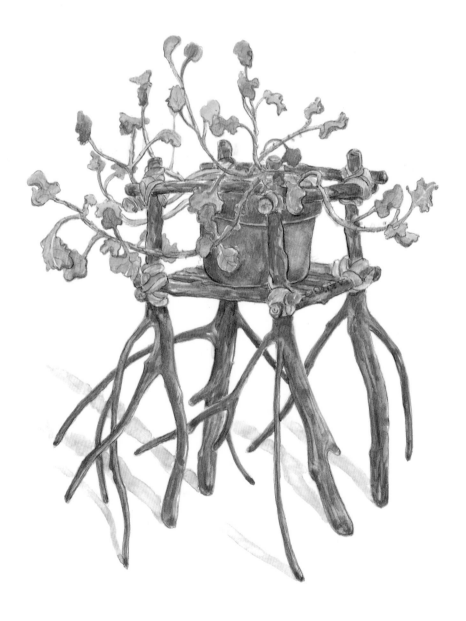

1. Arrange four of the 7-inch (17.5 cm) twigs to form a square 5 inches (12.5 cm) from corner to corner. Use a pencil to mark the bottom twigs where the top twigs cross. Cut notches in the bottom twigs. Apply glue to the notches and replace the top twigs. Let dry.

2. Repeat step 1 with the remaining 7-inch (17.5 cm) twigs, so that you have two twig squares.

3. Set one branched twig inside a corner of one twig square. The corner of the twig square should be just above the branching point. Apply glue to the points where wood meets and bind those junctures with wire or twine.

4. Repeat step 3 with the remaining branched twigs. You should now have a rough stand, with the forked ends as legs. At this point, the structure will be wobbly.

5. Place the remaining twig square over the structure, 1 inch (2.5 cm) down from the top of the stand. Apply glue to all points where wood meets. Bind with wire or twine. Straighten branching twigs and squares. Let dry in an upside-down position; prop or lean it if necessary.

6. Bind each of the eight corners with doubled, 30-inch (75 cm) strands of raffia. Wrap the raffia so that it covers the entire joint and the wire or twine binding. Raffia is strong and makes a tight bond, but if it breaks while you are working with it, just use another piece.

step 7 continued on next page

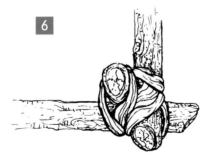

6

Each corner is glued and bound with wire or twine and then raffia.

Materials

Seventeen twigs:
- 8 straight twigs, ½" (1.3 cm) in diameter, 7" (17.5 cm) long
- 4 branching twigs with many forks, ½" (1.3 cm) in diameter at the base, with a 6" (15 cm) stem preceding any branching and 15" (37.5 cm) in over-all length (see below)
- 5 straight twigs, ¼" (.6 cm) in diameter, 6½" (16.3 cm) long

Wood glue (thick resin glue works best)

Twine or eighteen gauge wire

Raffia

Tools

Pencil
Pruning shears
Side-cut pliers
Scissors

Twig Techniques

Cutting
Notching
Gluing
Binding

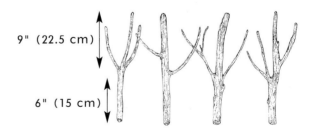

9" (22.5 cm)

6" (15 cm)

Four branching twigs with many forks

7. Glue the 6½-inch (16.3 cm) twigs evenly spaced across the bottom square to hold the pot. Let dry.

8. Hold the plant stand in a level, upright position, slightly above the surface of the table. Set the stand down, noting which branches are touching the table. Trim these first to even out the stand. Choose the sturdiest legs, one from each twig, to leave the longest. Trim the rest a bit shorter. If the stand rests on more than four legs, so much the better.

Variation for a 6-Inch Pot

To make a stand for a 6-inch (15 cm) pot, cut the eight straight twigs 9 inches (22.5 cm) long instead of 7 inches (17.5 cm). The straight section of the four branching twigs should be 8 inches (20 cm) long instead of 6 inches (15 cm).

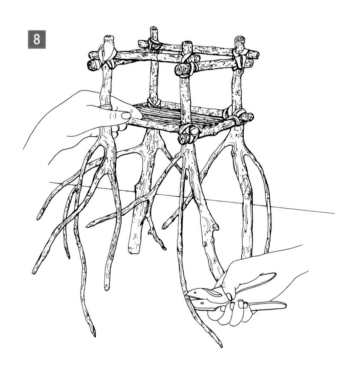

Trim the twig "legs" so the plant stand is level.

Espalier

Similar to topiaries, espaliers are plants, shrubs, or trees trained on a form flat against a wall. They were originally designed as space-saving, trellislike forms for growing fruit trees in medieval walled gardens. Our espaliers are made of crab apple twigs forming a symmetric pattern for trailing philodendrons. Create a pattern, like the example shown, by nailing or binding twigs together. Use twigs with many branching forks, and trim those forks to nubs. Supported by the forks, the plant can be trained to climb along the twigs.

A large espalier can be nailed to a wall, one piece or section at a time. Or assemble the entire espalier like a small trellis and hang it on the wall. As the climbing vines grow, train them up and out along the little forks of the espalier. For added supports, tack small nails in the espalier where needed.

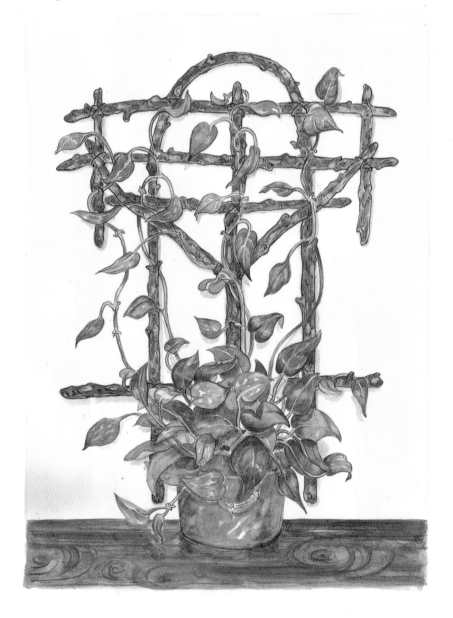

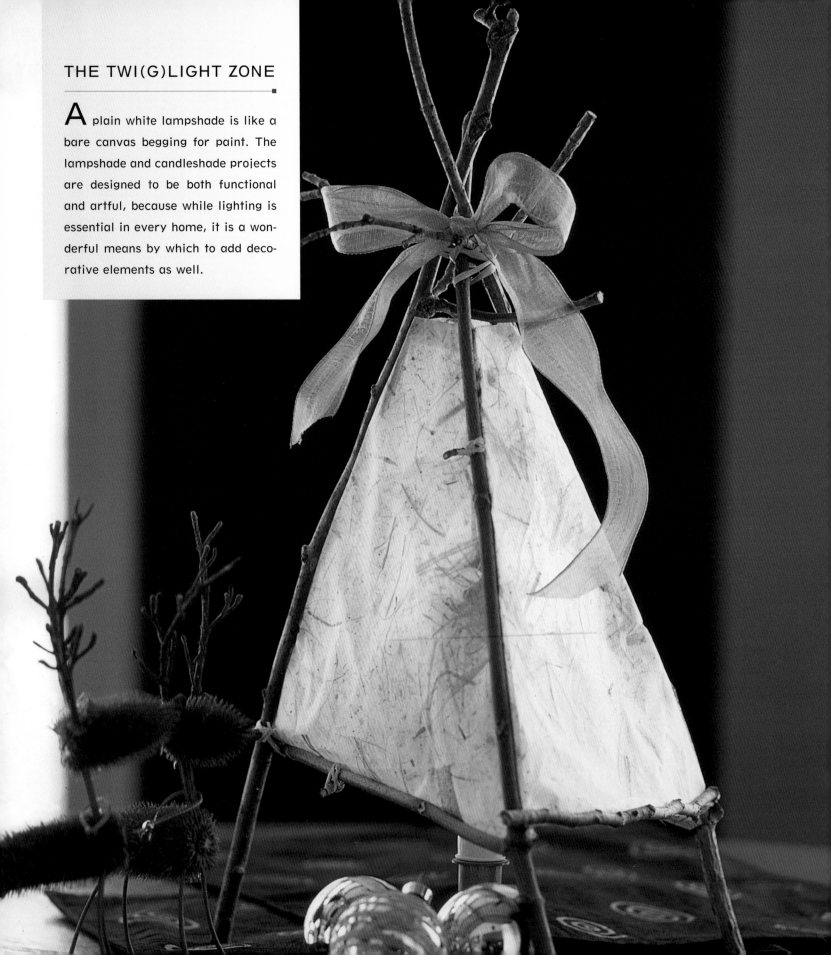

THE TWI(G)LIGHT ZONE

A plain white lampshade is like a bare canvas begging for paint. The lampshade and candleshade projects are designed to be both functional and artful, because while lighting is essential in every home, it is a wonderful means by which to add decorative elements as well.

Nature-Printed Lampshade

Nature printing is a great decorating technique, and our homes have nature-printed walls, fabrics, and framed art. A simple form of nature printing is leaf stamping, in which prints are made of leaves with a stamp pad. The leaf-stamping instructions for this project are excerpted from Laura's book, *Nature Printing with Herbs, Fruits & Flowers* (see page 118). Images of ferns were stamped on the lampshade at measured intervals, and grapevines frame each print, creating a paneled effect.

We started with a turned wood lamp base and purchased a lampshade to fit. It has a light-diffusing plastic liner covered with off-white muslin, a good fabric for nature printing. The grapevines are stitched to the shade with a darning needle and raffia for a decorative finish.

Choosing Materials

Leaves: Choose leaves that are the appropriate size for your lampshade. Fresh-picked, flat leaves with protruding veins work best. Good examples include:

- *Tree or vine leaves:* maple, sassafras, grape, Virginia creeper
- *Herb and flower leaves:* sage, geranium, lady's mantle, rose, foxglove, dusty miller, dandelion, fern

Lampshade: Nature printing requires hand pressure. A firm lampshade is easier to work with when printing leaves. You can use any size lampshade — just adjust the size of your leaves and materials accordingly. The lampshade we worked with, for which the vine lengths are suited, was 12 inches (30 cm) high with diameters of 6 inches (15 cm) at the top and 19 inches (47.5 cm) at the bottom.

Materials

Lampshade: white fabric over a stiff plastic liner
Leaves for nature printing
Foam sponge stamp pad
Copier paper or newsprint
Tweezers
Paper towels
Grapevine, ⅛ to ¼ inch (.3 to .6 cm) in diameter
- 6 18" lengths (45 cm)
- 1 20" length (50 cm)
- 1 7' length (2.1 m)
Raffia, natural color, about 10 yards (9 m)

Tools

Measuring tape: dress-makers, 6' (1.8 m) long
Pencil
Ruler
Pruning shears
Awl
Heavy-duty darning needle with a large eye
Scissors
Snap clothespins

Twig Techniques

Cutting
Bending

1. Beginning at the lampshade's seam, measure around the top opening of the shade, making six marks at evenly spaced intervals with a pencil. Measure around the bottom opening of the shade, making six more marks at evenly spaced intervals that match up vertically with the upper marks.

2. Using the ruler, draw a light pencil line to connect the marks from top to bottom, creating the six panels. These lines will be hidden by vines.

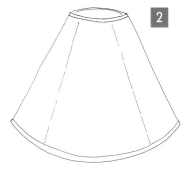

Section the lampshade into six panels.

step 3 continued on next page

3. Make some nature prints on paper first to help you visualize the final design you want. You may want to print the same leaf on each panel, a different leaf on each panel, or alternate leaf designs. When printing small leaves, stamp more than one to form a design on each panel.

To ink leaves, lay each leaf underside up on a piece of scrap paper. Hold the edge of the stem with fingers of one hand. In your other hand, hold the stamp pad upside down and repeatedly press the pad onto the leaf until a layer of ink covers the leaf. Don't saturate the leaf with ink or the leaf's texture will not appear when it is stamped.

Carefully remove the leaf from the stamp pad with tweezers. Lay the leaf

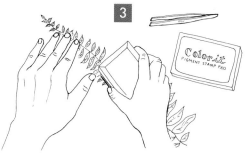

To ink leaves, press the stamp pad onto the leaf.

inked side down on a sheet of paper to make a test print. Cover the leaf with another piece of paper and press all around with your fingers or the heel of your hand. Remove leaf with tweezers. (Keep your hands clean with paper towels and water.) When you are satisfied with your test prints, repeat the nature print procedure on the panels of the lampshade; let them dry before moving on to step 4.

4. Hold an 18-inch (45 cm) length of vine against one of the vertical lines marked on the lampshade. Adjust the vine to judge the best area to use for the shade. Let the lampshade guide your measuring and trimming of each length. Cut vine ½ inch (1.3 cm) shorter than shade height.

5. Hold the trimmed vine to the shade and use the pencil to mark three or four spots, evenly spaced up the height of the shade, on both sides of the vine.

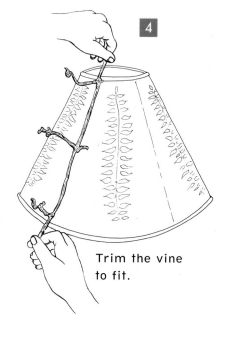

Trim the vine to fit.

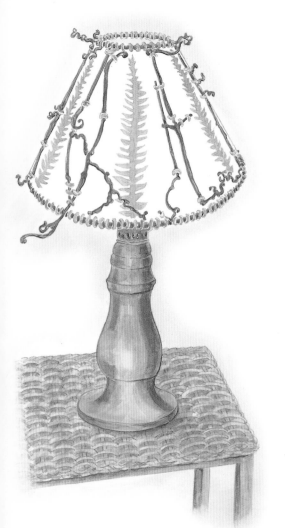

6. Use the awl to puncture the shade at the pencil marks. Thread a darning needle with a 24-inch (60 cm) length of raffia: Pull 6 inches (15 cm) through the darning needle's eye, and trim the raffia to leave an 18-inch (45 cm) tail. Do not make a knot. This will allow you to sew with one strand.

7. Hold the vine in place on the lampshade. Poke the needle up from inside the shade through one of the holes next to the vine and pull the raffia through. Leave a 2-inch (5 cm) tail of raffia inside the shade. On the opposite side of the vine, poke the needle back to the inside, pulling raffia through. Trim with scissors, leaving another 2-inch (5 cm) tail. Tie the two tails in a square knot. Trim the ends with scissors. Continue sewing through all of the holes until the vine is secured to the shade.

8. Repeat steps 4 through 7 for the five remaining 18-inch (45 cm) vines.

9. Hold the 7-foot (2.1 m) length of vine around the bottom edge of the shade with snap clothespins. Trim the vine to fit around the shade without overlapping. Just above the vine, puncture holes in the shade with the awl every ½ inch (1.3 cm) all the way around the bottom. Use the measuring tape if needed.

10. Thread the needle with a length of the raffia and tie a knot 2 inches (5 cm) from the end of the longest tail. Pull the needle through a hole from inside the shade. Loop the raffia down under the bottom edge of the shade, catching the vine as you sew. Return to the inside of the shade, poke the needle through the next hole. Continue around until completed, removing clothespins as you go. Rethread the needle if necessary, tying together with the previous length. When you come to the starting point, remove the needle and tie the two tails together. Trim ends with scissors.

11. Repeat step 10 for the top edge of the shade, using the 20-inch (50 cm) length of vine. If necessary, sew tendrils or any added vines with raffia as described above.

 Note: The characteristic tendrils of the grapevine add personality to this project. Long tendrils extending across the lampshade should be secured with raffia as described in step 7.

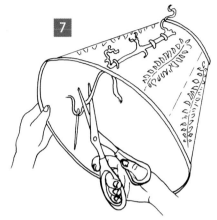

Sew the vine in place with raffia.

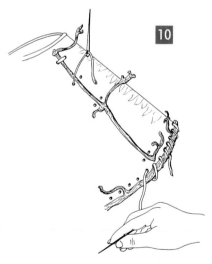

Use a decorative looping pattern to stitch the vine around the base and the top.

Candleshade

We like the welcoming glow of electric candles in every window in the house at holiday time. A few windows keep the candles all year to glimmer in the evening.

Combining a candleshade with an electric candle creates an unusual mood light that is an artful object for an end table, nightstand, or wall shelf. Binding the structure with forked twigs makes it much sturdier than using separate crosspieces. The shade is made by form fitting translucent art paper to the twig structure. Check art or craft supply stores for decorative papers. We used a thin but strong Asian paper containing pieces of wood and bark, and attached it to a sassafras-twig frame. Use the straightest twigs you can find to easily custom fit the paper shade. Battery-operated or electric candles are very inexpensive, range from about 7 to 9 inches (17.5 to 22.5 cm) tall, and use 7½-watt bulbs. Purchase them wherever holiday items are sold.

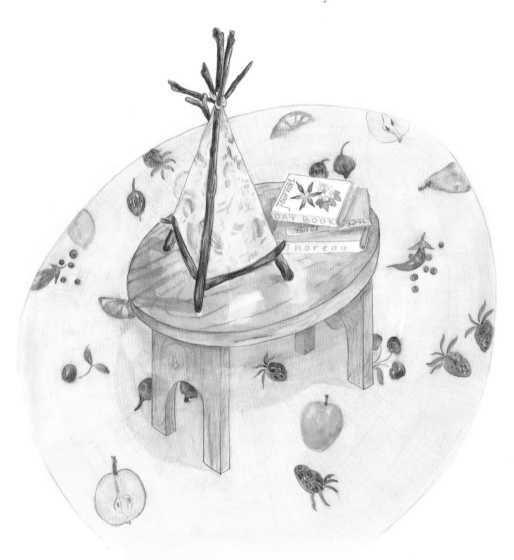

1. Set up the twigs teepee-style, crossing at 16 inches (40 cm) from the bottom. Position them so they will remain freestanding. Bind securely with raffia where the three twigs cross.

2. Adjust the distance between the twigs to about 9 inches (22.5 cm) apart at the base. Bend one of the base forks gently but firmly to meet its neighboring twig. Bind this cross point with raffia.

3. Repeat step 2 with the two remaining forks to create a structure containing three triangular sections.

4. Place a sheet of paper over one of the triangles (if the paper has a "front" side, it should be facing out). Fold paper around the sides and base twigs, forming creases. Remove the paper and trim along the crease marks with scissors. You now have one section of the custom-fit shade.

Materials

Three straight twigs,
 ½-inch (1.3 cm) diameter,
 20 inches (50 cm) long
 with a flexible fork ½
 inch (1.3 cm) from base
 and extending 10 inches
 (25 cm) (see below)
Raffia
Decorative paper, such as
 strong, translucent art
 paper
White glue
Electric candle (and
 battery, if needed)

Tools

Pruning shears
Measuring tape
Scissors

Twig Techniques

Cutting
Bending
Binding

step 5 continued on next page

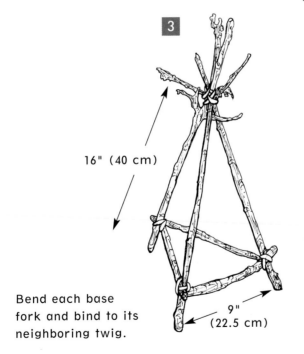

3

16" (40 cm)

9" (22.5 cm)

Bend each base fork and bind to its neighboring twig.

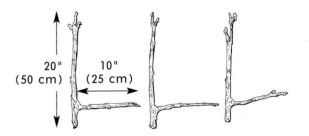

20" (50 cm) 10" (25 cm)

The tops of the three twigs can be forked.

Candleshade continued

5. Fold each edge in about ¼ inch (.6 cm). Place the shade section against the triangle to measure the fit. The outside edge of the folds should fit within the sides of the twigs. Trim and refold areas for a close fit.

6. Apply a thin, straight line of white glue along the inside of one twig. Place the outside edge of the fold along the glue line. Work from both outside and inside the candleshade to form fit the paper. Repeat this step along the two other twigs, securing the paper on all sides.

7. Repeat steps 4 through 6 for the two remaining triangles. Place the shade over the electric candle. Center the candle and make sure that the bulb is not touching the paper.

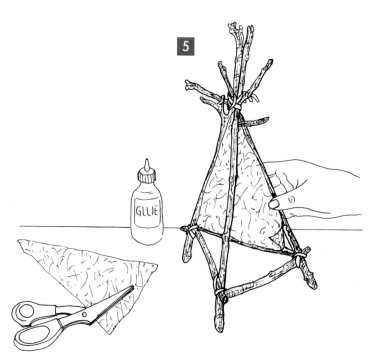

Glue a paper triangle to each twig triangle.

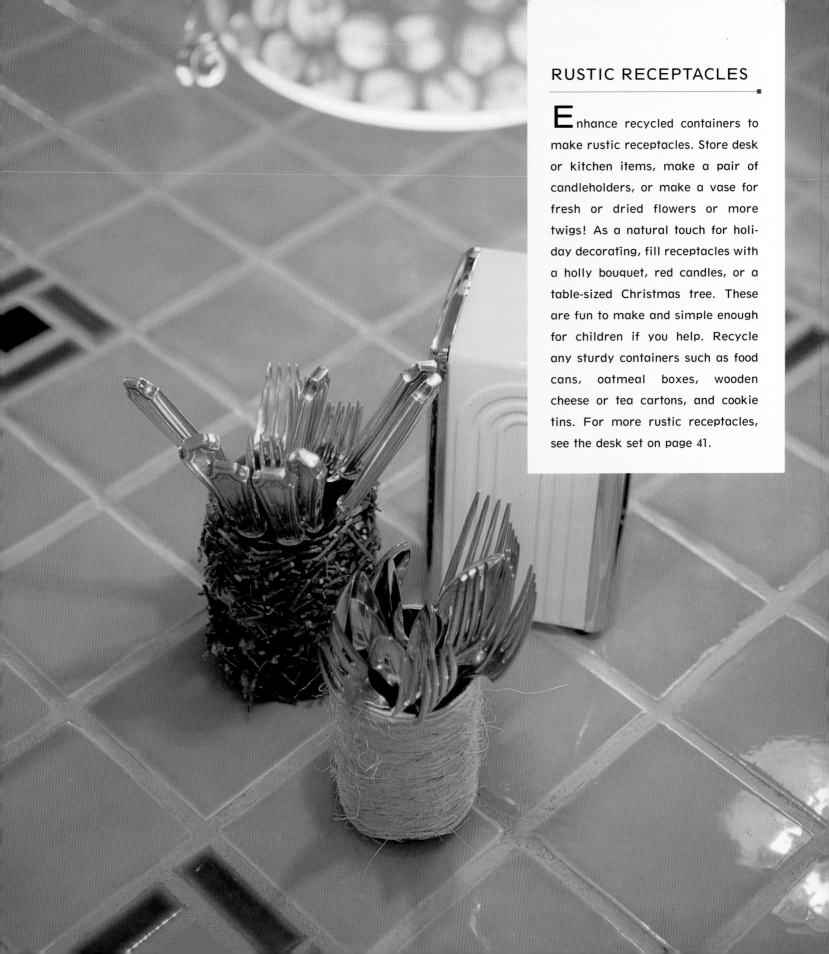

RUSTIC RECEPTACLES

Enhance recycled containers to make rustic receptacles. Store desk or kitchen items, make a pair of candleholders, or make a vase for fresh or dried flowers or more twigs! As a natural touch for holiday decorating, fill receptacles with a holly bouquet, red candles, or a table-sized Christmas tree. These are fun to make and simple enough for children if you help. Recycle any sturdy containers such as food cans, oatmeal boxes, wooden cheese or tea cartons, and cookie tins. For more rustic receptacles, see the desk set on page 41.

Twiglet Receptacle

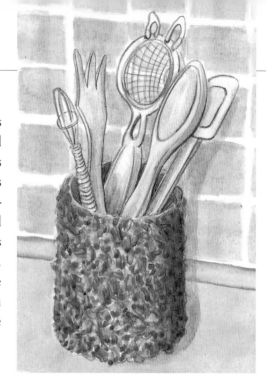

To make twiglets, sweep all the bits of twigs on your work table into a shallow cardboard box. Add to this by snipping up leftover twigs with pruning shears. A mix of tiny twigs and bits of chunkier twigs, up to ¼ inch (.6 cm) in diameter, will give your receptacle a more textured appearance. Our twiglet box also includes bits of leaves, wire, twine, colored papers, and sand. Plan to make a few receptacles at a time. The layering technique requires time in between layers to allow the glue to dry. Or use a hot glue gun and glue sticks to eliminate waiting.

Materials

Construction paper:
 black or brown, 10
 inches by 5½ inches
 (25 by 13.8 cm)
Spray adhesive
Empty soup can, 3 inches
 (7.5 cm) in diameter
 by 4½ inches (11.3 cm)
 high
Black or brown magic
 marker
Box of twiglets
Wood glue, white glue, or
 glue sticks
Twig or popsicle stick
Spray acrylic sealer,
 matte or gloss

Tools

Scissors
Glue gun (optional)

Twig Techniques

Cutting
Gluing
Finishing

1. Create 1-inch (2.5 cm) tabs in the construction paper by cutting 1-inch (2.5 cm) slits every inch along one of the long sides. Apply spray adhesive to the paper, following label directions. Wrap paper around the can with the tabs at the top. Fold each tab over the top edge and press to the inside of the can. If the metal lip shows at bottom, color it with a marker.

2. Place the receptacle on its side in the twiglet box. Drizzle glue on one side of the receptacle and spread with a twig or popsicle stick. Roll glued side into twiglets. Spread glue on the area of the can now facing up and drop twiglets onto the glue. Leave receptacle in place to dry.

3. Repeat step 2 until a layer of twiglets covers the paper. Build up two or three layers, letting the glue dry in between each layer.

4. Apply glue where paper shows through and place twiglets by hand to fill the gaps. Continue until you are satisfied with the result. Let dry completely.

5. Apply spray acrylic sealer, following label directions.

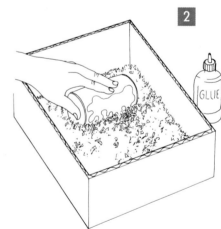

Coat the container one
section at a time.

Twine Receptacle

A simple wrapping technique using recycled containers that are just the right size to make candleholders for a pair of candles 3 inches (7.5 cm) in diameter.

1. Apply a thin line of glue along the bottom edge of the receptacle. Wrap twine along the glued edge.

2. Apply glue sparingly and continue to wrap the twine evenly around and toward the open end of the receptacle.

3. Apply a thin line of glue along the top edge to finish. Cut the twine with scissors and seal the end with glue. Let dry.

4. Repeat steps 1 through 3 for the second receptacle.

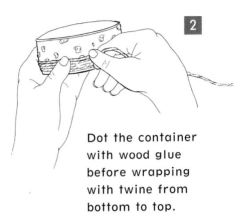

Dot the container with wood glue before wrapping with twine from bottom to top.

Materials
Two empty tuna cans: 6-ounce (170 g) size
Wood glue or glue sticks
Twine: about 60 inches (1.5 m)

Tools
Scissors
Hot glue gun (if using glue sticks)

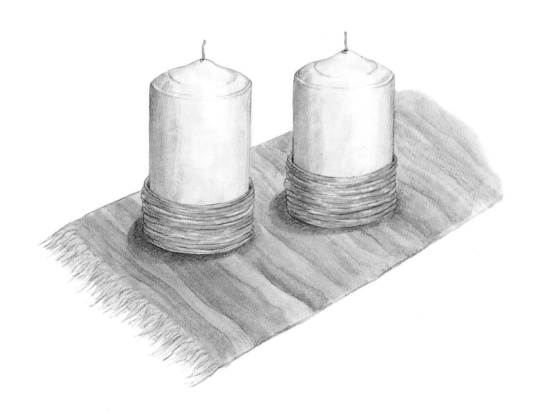

Twig Receptacle

To hold fresh-cut flowers, choose a glass or plastic container that is smaller than your twig receptacle and fill it with water. Place it in the receptacle and arrange flowers, like the blooming tree branches shown here.

1. Paint the coffee can to create a neutral background for the twigs. Let dry.

2. Apply glue to the receptacle in a vertical line and place a twig on the glue. Hold it in place for a few seconds. Continue applying twigs around the receptacle until it is covered. Apply the twigs so that they are flush with the bottom of the can and produce a ragged, natural look around the top.

3. Wrap a length of raffia around the receptacle and tie with a square knot or bow.

Materials

Empty coffee can, open at top

Spray paint or jar of craft paint: black, brown, or gray

30 to 40 twigs, ⅛- to ¼-inch (.3 to .6 cm) diameter, varying from 6 to 8 inches (15 to 20 cm) long or all one length

Raffia

Tools

Pruning shears

Paintbrush (if using jar paint)

Hot glue gun and glue sticks

Twig Techniques

Cutting

Gluing

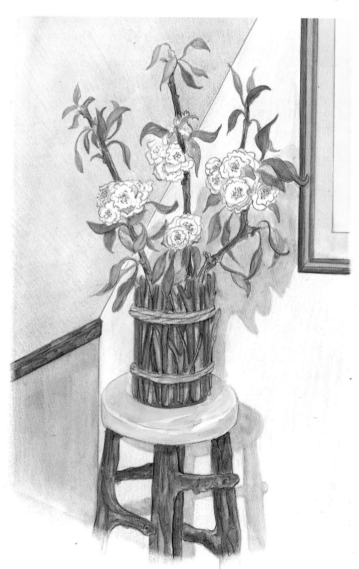

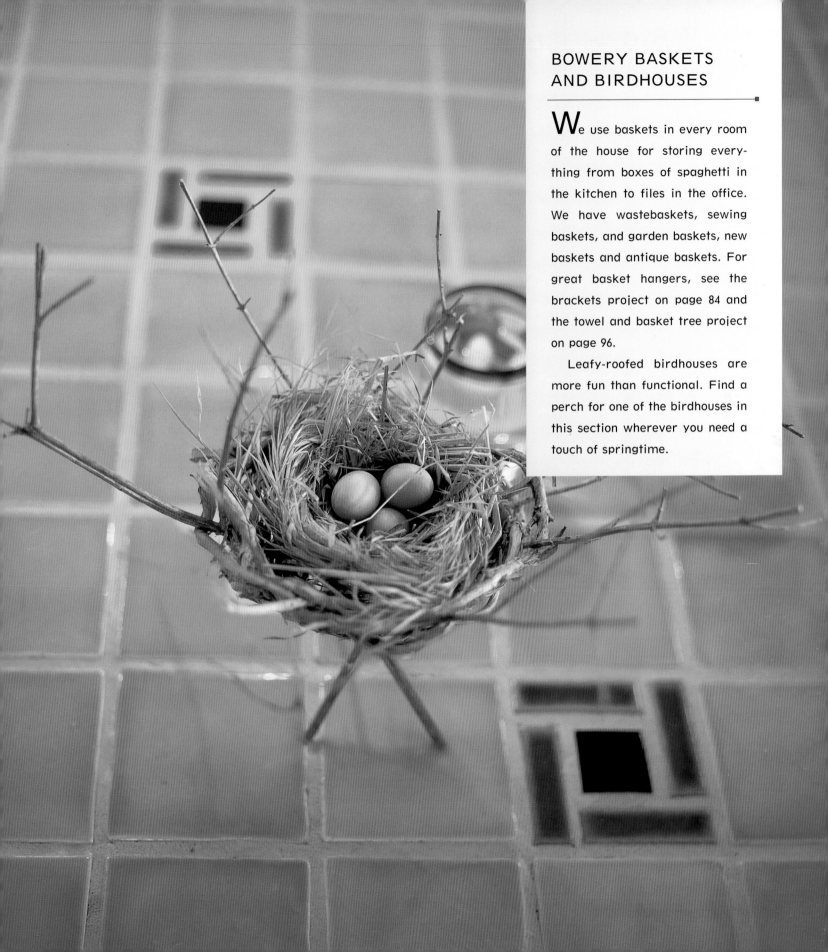

BOWERY BASKETS AND BIRDHOUSES

We use baskets in every room of the house for storing everything from boxes of spaghetti in the kitchen to files in the office. We have wastebaskets, sewing baskets, and garden baskets, new baskets and antique baskets. For great basket hangers, see the brackets project on page 84 and the towel and basket tree project on page 96.

Leafy-roofed birdhouses are more fun than functional. Find a perch for one of the birdhouses in this section wherever you need a touch of springtime.

Footed Basket

Materials

Three twigs containing
 three forks each for a
 total of nine ribs, ¼-inch
 (.6 cm) diameter, 14
 inches (35 cm) long
 (see below)
Rubber band about 3
 inches (7.5 cm) long
Vines (remove leaves
 and coil lengths into
 two circles for ease
 when working):
 ■ narrow, smooth vine
 about ¹⁄₁₆" (.2 cm) diam-
 eter, 4' (1.2 m) long
 ■ thicker, shaggy vine
 up to ¼-inch (.6 cm)
 diameter, 4 feet
 (1.2 m) long

Tools

Ruler
Pruning shears

Twig Techniques

Cutting

Use twigs that branch in an opposite,
rather than an alternate, pattern —
trim any side twigs from the bottom
4" (10 cm) of the twig stems.

One sunny, cold day in March, while Laura was busy working on a project at her house, I wandered around my yard examining the branching forms of the trees and shrubs with the idea of making a basket. The dormant butterfly bush provided me with forked branches and appealing twiggy ends for the basket ribs. The supple, strong vines of the woodbine became my weaving material. I cut some narrow, smooth new growth and thicker, shaggy older vine for weaving and sat in the sun at my table near the window to make this 11-inch (27.5 cm) high basket that celebrates twigs and vines.

— from Ann

1. Hold the three twigs together. Double the rubber band and wrap it around the stem 3 inches (7.5 cm) up from the bottom. Stretch the rubber band out and twist it around again for a firm hold. Spread the base of the three twigs and hold them apart with one hand. You may have to loosen the rubber band if it's too tight.

2. Begin weaving with the narrow vine from inside the basket, ½ inch (1.3 cm) above the forked branches. Place one end of the vine under a rib, then over the next one. Keep the base of the twigs spread apart with one hand as you weave. Use the thumb and forefinger of this hand to hold the starting end of the vine in place as you weave with the other hand to complete the first row.

Holding the bases of the twigs spread apart
with one hand, begin weaving through the
tops with an over-under pattern.

3. Continue around in this manner, being careful not to weave too tightly. When you come around again to where you began, go *over* the rib. If the vine breaks, tuck the broken end behind the previous rib. Pick up weaving where you left off and continue until you have reached approximately 1½ inches (3.8 cm) up the ribs. End with a vine tucked under a rib and snip it off from underneath.

4. Start weaving with the thicker vine, beginning where you left off. Proceed as in steps 2 and 3. When you have woven about another 1½ inches (3.8 cm), tuck the vine under a rib and cut it with shears. Cut the rubber band and remove. If necessary, trim the legs so the basket stands evenly. Snip any unwanted twiggy ends off the top.

Basketry 101

When gathering twigs for a basket, you need to collect an odd number of ribs. The weaving process is a simple matter of bringing the vine over and under the ribs, until you come around to the beginning again. The weaving vine will continue above the previous row but in the opposite way (either under or over) of the one below it, and so the need for an odd number of ribs.

Handled Basket

Planted in containers, twigs inhabit the corners of my studio ready and waiting to be made into twig things. When I happened to come across two twigs with very similar angles that made me think of handles, I designed this 9-inch by 12-inch (22.5 by 30 cm) basket around them. I selected straight twigs of birch, cedar, and maple. The only problem was that the twigs had been waiting around too long. Once cut, green wood begins to dry and harden, making it difficult to hammer in nails. Glue, wire, and raffia secured this project well, making a sturdy basket. The combination of notching, gluing, and binding works well for many projects when nailing is difficult.

— *from Laura*

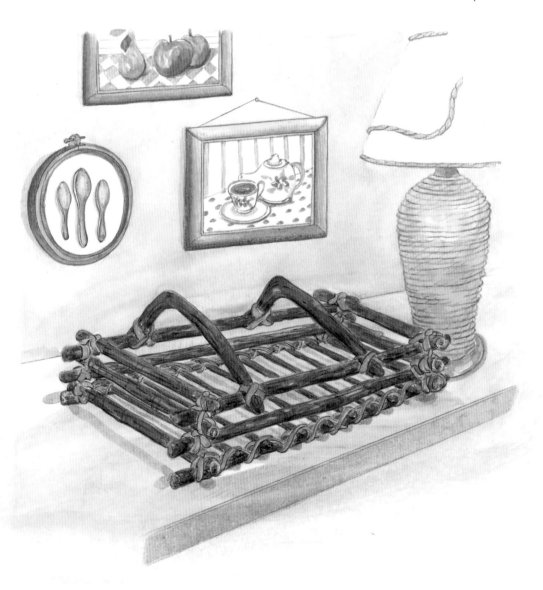

1. Place two of the 12-inch (30 cm) twigs opposite each other, 7 inches (17.5 cm) apart. Place two of the 9-inch (22.5 cm), ½-inch (1.3 cm) diameter twigs on top to form a rectangle. Use a pencil to mark the bottom twigs where the top twigs cross. Cut notches, apply glue to each notch, and replace top twigs. Let dry.

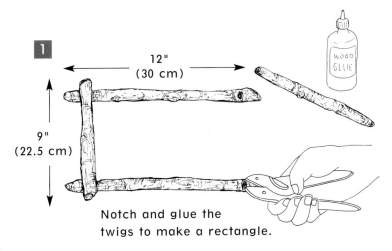

12"
(30 cm)

9"
(22.5 cm)

Notch and glue the
twigs to make a rectangle.

2. Repeat step 1 with the remaining ½-inch (1.3 cm) diameter twigs to make a total of three rectangles.

3. Choose one of the rectangles as the base. Lay the remaining 9-inch (22.5 cm) twigs evenly spaced between the 12-inch (30 cm) twigs that form the sides of the rectangle. Glue them in place, and let dry.

4. Tie wire to one corner of the base rectangle and wrap it along the length of one of the 12-inch (30 cm) twigs, wrapping over each of the 9-inch (22.5 cm) twigs. Tie at the other end and snip off any excess.

5. Tie raffia to the same corner and wrap it along the twig in the opposite direction, again wrapping over each of the 9-inch (22.5 cm) twigs. Tie at the other end and snip off any excess. Repeat steps 4 and 5 on other side.

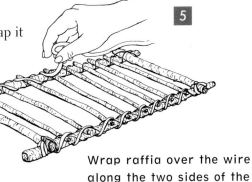

Wrap raffia over the wire
along the two sides of the
basket base.

step 6 continued
on next page

Materials
Twenty-two twigs:
- 6 straight, ½" (1.3 cm) diameter, 12" (30 cm) long, and trimmed of branching forks
- 6 straight, ½" (1.3 cm) diameter, 9" (22.5 cm) long, and trimmed of branching forks
- 8 straight, ¼" (.6 cm) diameter, 9" (22.5 cm) long, and trimmed of branching forks
- 2 similarly angled, ½" (1.3 cm) diameter, 10" (25 cm) long

Wood glue
Twenty-four gauge wire
Raffia

Tools
Pencil
Pruning shears
Side-cutting pliers
Scissors

Twig Techniques
Cutting
Notching
Gluing
Binding

Handled Basket continued

6. Place the other two rectangles on top of the base rectangle, creating the sides of the basket. Bind each corner with raffia to secure the three rectangles: Begin at the bottom from underneath the basket. Weave the raffia up to the top. Cross over top and wind back down to the base, crisscrossing each rectangle. Tie a square knot underneath.

7. Set the handles in place, 3 inches (7.5 cm) from each end on the long side. Bind with raffia, crisscrossing the four joints.

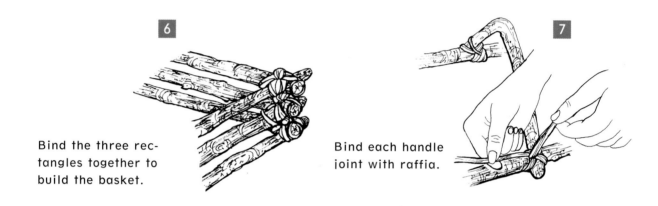

Bind the three rectangles together to build the basket.

Bind each handle joint with raffia.

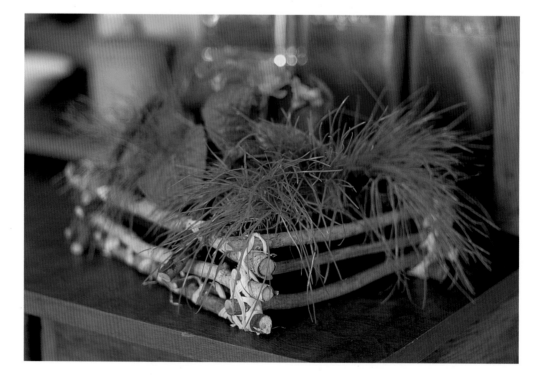

Birdhouse

This project is designed as an indoor, decorative accessory, and is a variation of the handled basket. The construction begins with a square made up of four twigs, and is topped with angled twigs to form the roof. Dry leaves create the shingles. We used dry aspen leaves and huckleberry twigs for a finished size of 7 inches (17.5 cm) by 11 inches (27.5 cm) high. Some birds reuse their nests from year to year, but if you're lucky enough to find an abandoned bird nest — one that's been blown from its perch — put it inside your birdhouse. You can also find crafted bird nests in craft stores, or try making your own.

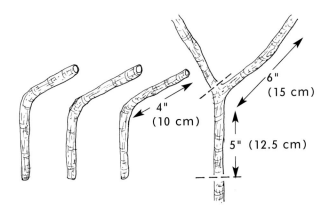

Find four twigs with angles that match. Trim the bottom stems to 5 inches (12.5 cm) long. Trim the matching angles to 4 inches (10 cm), except for one trimmed to 6 inches (15 cm) — this will become the "chimney."

1. Form a square with four of the 7-inch (17.5 cm) twigs. Space the twigs 6 inches (15 cm) apart. Use a pencil to mark the bottom twigs where top twigs cross. Cut notches and apply glue to each notch. Replace top twigs and let dry.

2. Bind each of the four corners with wire. Place one of the angled twigs inside and in line with a corner of the square. Bind the joint where the three twigs meet with raffia.

step 3 continued on next page

Materials

Nineteen twigs:
- 6 straight, ½" (1.3 cm) diameter, 7" (17.5 cm) long
- 4 Y-shaped forked, ½" (1.3 cm) diameter
- 9 straight, ¼" (.6 cm) diameter, 8" (20 cm) long

Wood glue
Twenty-four gauge wire
Raffia
Leaves: dry and relatively flat, enough to shingle the roof of your house
Vine: 5 feet (1.5 m) long with plenty of tendrils (optional)

Tools

Pencil
Pruning shears
Side-cutting pliers
Scissors

Twig Techniques

Cutting
Notching
Gluing
Binding

Birdhouse continued

3. Place another angled twig in the opposite corner to meet the first angled twig, forming one of the roof gables. Bind the joint where three twigs meet with raffia. Bind where the twigs cross at the roof peak with wire.

4. Repeat steps 2 and 3 on the opposite side with remaining angled twigs.

5. Apply glue to the top of each gable. Place an 8-inch (20 cm) twig across the top, forming the roof ridge. Bind the two joints with raffia. Place a 7-inch (17.5 cm) twig across the base of the roof and bind with raffia. Repeat with the remaining 7-inch (17.5 cm) twig on the opposite side.

6. Cut four evenly spaced notches on each end of the roof gable, two on each slope of the roof, for a total of eight. Apply glue, and set four of the remaining twigs in place, two on each slope. Bind these joints with wire or raffia.

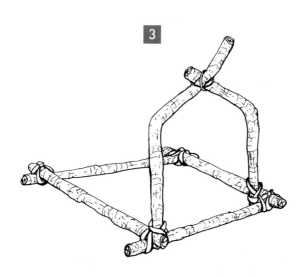

Bind the angled twigs and cross at the top to form the roof gable.

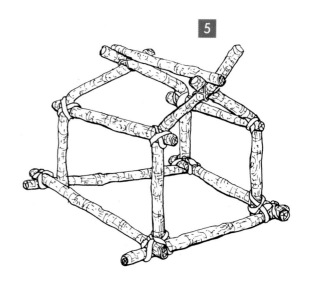

Set twigs horizontally to form the ridge and two bottom edges of the roof.

7. To "shingle" the roof, begin at the bottom and work toward the peak. Apply a line of glue along each of the four cross beams and ridge. Place an overlapping row of leaves along the bottom edge of the roof with leaf stems pointing up to the roof ridge. Apply glue to leaves where they overlap. Depending on the size of your leaves, place two or three more rows until you reach the peak. Allow the leaf stems to extend up and out. Let dry. Wind a short length of vine around the "chimney."

8. To make the floor, evenly space four of the 8-inch (20 cm) twigs across the base, laying them parallel to the roof's cross beams. Glue them into place and let dry. Wind a longer length of vine around the base of the house, if desired.

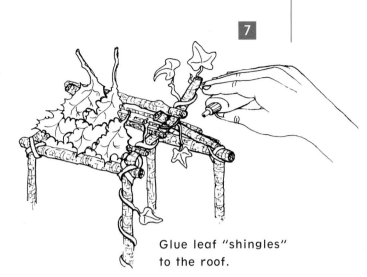

Glue leaf "shingles" to the roof.

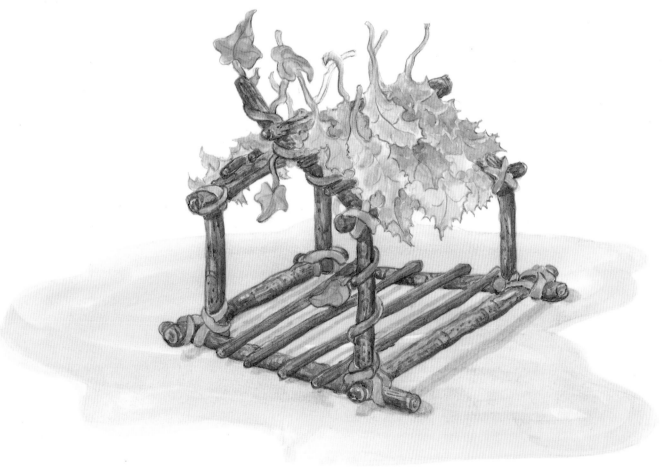

Twigged Birdhouse

Materials

Twigs or vines
Ready-made birdhouse
Wood glue
Dry, flat tree leaves,
 enough to shingle
 your house

Tools

Pruning shears

Twig Techniques

Cutting
Gluing

Any ready-made birdhouse can be quickly converted into a twiggy birdhouse. Glue twigs to the edges and corners of your birdhouse and shingle the roof with dry leaves. Or simply wrap vines around the house, making it a house within a nest!

1. Measure each twig by holding it against the corner where you intend to attach it. Cut twig to size with shears and glue in place. Glue twigs to all corners and edges of house.

2. Starting at the bottom edge and working your way to the peak, shingle the roof. Glue a row of overlapping leaves, allowing this first row to hang off the edges of the roof. Glue another row above the first and continue until the roof is covered. Allow the leaf stems to extend up and out over the ridgeline.

To make a "nest house": Simply wrap vines around the base, tucking the ends under to hold in place. Glue vines to circle the bird's entrance hole. Shingle the roof with leaves as in step 2 above.

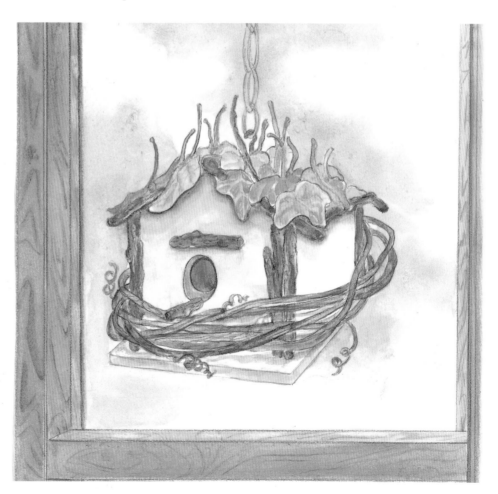

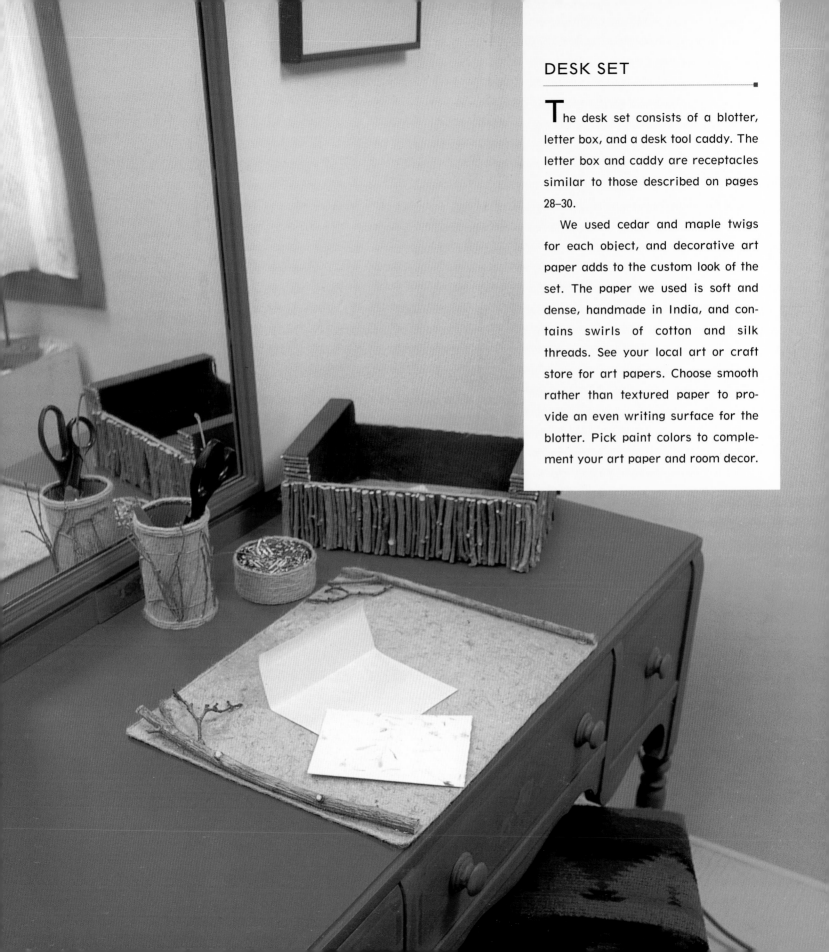

DESK SET

The desk set consists of a blotter, letter box, and a desk tool caddy. The letter box and caddy are receptacles similar to those described on pages 28–30.

We used cedar and maple twigs for each object, and decorative art paper adds to the custom look of the set. The paper we used is soft and dense, handmade in India, and contains swirls of cotton and silk threads. See your local art or craft store for art papers. Choose smooth rather than textured paper to provide an even writing surface for the blotter. Pick paint colors to complement your art paper and room decor.

Letter Box

The recycled container we used is a wooden clementine crate from the supermarket. Any small crate or very sturdy shoe box will work well. Make sure it is large enough to hold your notecards, envelopes, or stationery. Ours is painted green on the inside and brown on the outside as a background for the twigs.

Never a day passes but that I do find myself the honor to commune with some of Nature's varied Arms.

— George Washington Carver

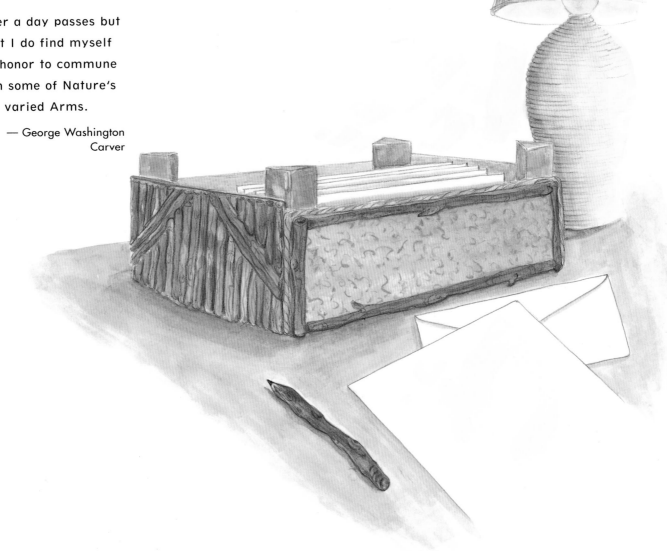

1. Paint the container, except for the inside bottom and outside front where the paper will be applied. Let dry.

2. Measure the inside bottom and outside front of the container and cut paper to size. Apply spray adhesive to the underside of each piece of paper, set, and press in place.

3. Measure the height and width of each section (except the front) on the outside of the letter box and cut twigs to size. Set letter box front side down, apply glue to the back side (which is face up), and apply twigs. Let dry. Repeat for each side except the front.

4. To frame the front paper panel, measure the height and length of the front side. Cut four twigs to size and glue them around the edges of the panel. Let dry.

5. If narrow edges show around the top and corners of the twig frame just applied to the front panel, give it a finished look: Apply a thin line of glue along each edge and place twine along the glue line. Let dry.

Materials

Wooden or heavy cardboard container
Spray paint or jar of acrylic craft paint
Decorative paper: the same used for other desk set items, pieces cut to size as described
Spray adhesive
Wood glue
Twigs — lots of small ones
Twine

Tools

Paintbrush (if using jar paint)
Ruler
Pencil
Scissors
Pruning shears

Twig Techniques

Cutting
Gluing

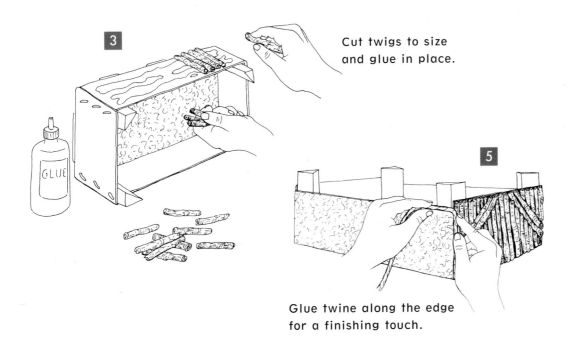

Cut twigs to size and glue in place.

Glue twine along the edge for a finishing touch.

Blotter

The base for the blotter is a sheet of cardboard that can be obtained from the back of a large drawing pad or purchased from an art or craft supply store. Our blotter is 12 by 15 inches (30 by 37.5 cm), but you can size materials to fit your desk space.

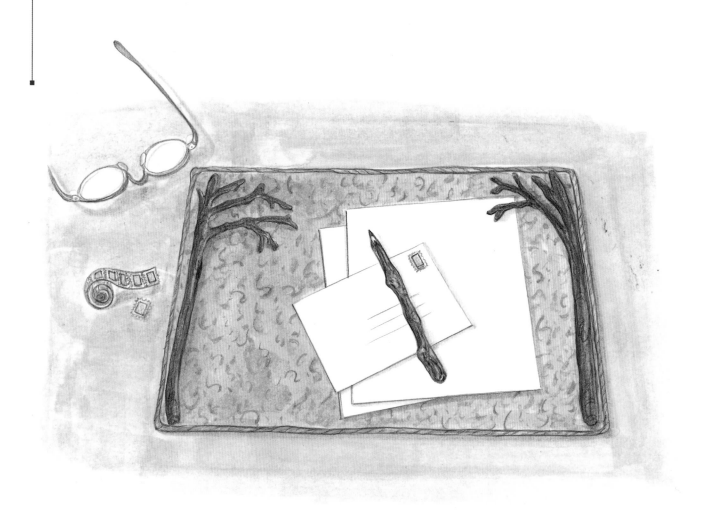

1. Apply spray adhesive to the back side of the paper according to label directions. Center cardboard on paper, leaving a 1-inch (2.5 cm) margin all around, and press to adhere. Cut the corners off the paper. Fold paper margins around the cardboard edges and press.

2. Stand blotter on one side. Apply a thin, straight line of white glue along the edge. Be careful not to drip glue onto the paper surface. Place twine along the glue line. Turn blotter 90 degrees and repeat on an adjacent side. Lay the blotter flat to apply glue and twine to the two remaining sides. Let dry.

3. Place a 12-inch (30 cm) twig on each side of the blotter. Note where the twigs touch the blotter and use wood glue on those spots to secure them in place. Place small twigs at the top of the blotter and glue in place. Let dry.

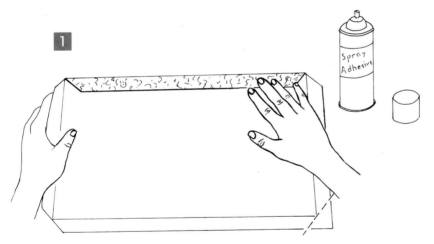

Fold the margin of decorative paper to the back of the blotter and press in place.

Materials

Decorative paper with a smooth surface, 14 by 17 inches (35 by 42.5 cm)
Spray adhesive
Cardboard sheet (not corrugated), 12 by 15 inches (30 by 37.5 cm)
White glue
Twine: about 55 inches (1.4 m)
Four twigs:
- 2 shapely, 12" (30 cm)
- 2 forked, 4" (10 cm)
Wood glue

Tools

Scissors
Pruning shears

Twig Technique

Gluing

Desk Tool Caddy

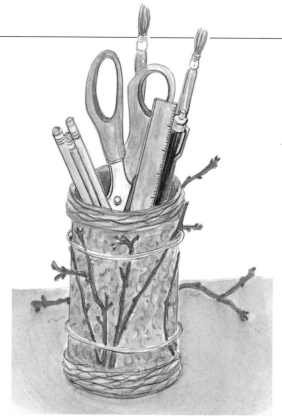

Strategically placed twigs, clipped just when buds were beginning to form in the spring, and the combination of materials make this an artful and functional object for your desk.

Materials

Empty soup can
Decorative paper: the
 same used for other
 desk set items
Spray adhesive
Wood glue: yellow
Twine
Twigs: a selection of
 small, forked twigs
Wood glue: thick, resin
 glue works best for
 applying twigs
Twenty-four gauge wire

Tools

Measuring tape
Pencil
Scissors
Pruning shears
Side-cutting pliers

Twig Techniques

Cutting
Binding
Gluing

1. Measure the height and circumference of the soup can. Add an extra ¼ inch (.6 cm) to the circumference measurement. Mark your paper and cut it to size. Apply spray adhesive to the back side of the paper, following label directions. Attach the paper to the soup can, overlapping the extra ¼ inch (.6 cm). The paper doesn't need to line up perfectly along the top and bottom edges, as the edges will be trimmed with twine.

2. Apply a line of yellow wood glue around the bottom edge of the receptacle. Place a length of twine evenly along the edge and spiral upward three times around, spot gluing as necessary to hold twine in place. Repeat for the top, beginning at the uppermost edge and spiraling downward three times around. Let dry.

3. Select a twig, hold it to the receptacle vertically and cut it to fit between the borders of twine. Apply resin wood glue to the twig and press it to the receptacle. Hold the twig in place for a few seconds. Repeat, applying twigs in a random, decorative pattern around the receptacle.

4. Cut two lengths of wire 3 inches (7.5 cm) longer than the receptacle circumference. Wrap one piece of wire approximately 1 inch (2.5 cm) down from the top. Wrap the other piece 1 inch (2.5 cm) up from the bottom. Bind and twist with side-cutting pliers. Trim excess wire and bend in cut ends so they are not exposed. Insert additional twigs behind the wire, if desired.

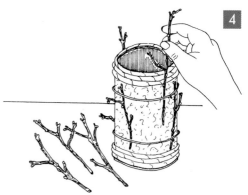

Insert more twigs behind
the wire wraps as desired.

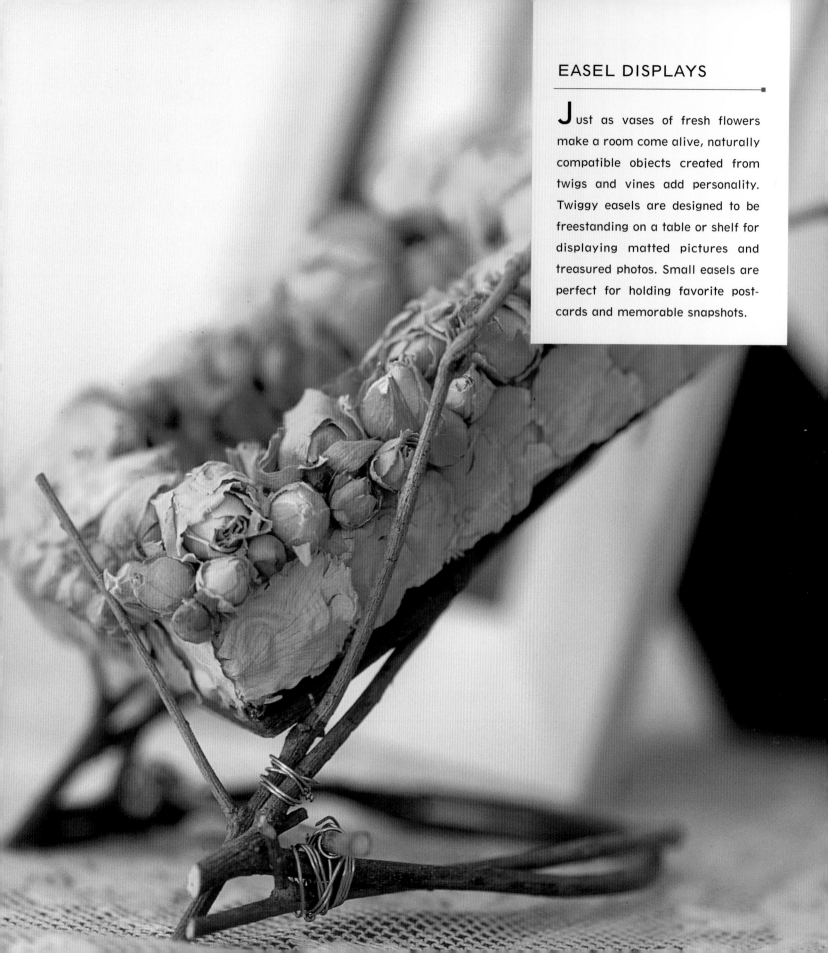

EASEL DISPLAYS

Just as vases of fresh flowers make a room come alive, naturally compatible objects created from twigs and vines add personality. Twiggy easels are designed to be freestanding on a table or shelf for displaying matted pictures and treasured photos. Small easels are perfect for holding favorite postcards and memorable snapshots.

Twiggy Easel

Materials

Seven twigs, ¼-inch (.6 cm) diameter, very flexible (see below):
- 2 with main stem 18" (20 cm) long, and 12" (30 cm) forks at 1½"(3.8 cm) from base of main stem
- 1 straight, 8" (20 cm)
- 2 with main stem 18" (45 cm), and 1½" (3.8 cm) forks at 1½" (3.8 cm) from base of main stem
- 1 with a Y at one end, 10" (25 cm) long
- 1 with a Y at one end, 4" (10 cm) long

Twenty-four gauge wire
Rubber band, 3 inches (7.5 cm) long
Raffia

Tools

Pruning shears
Side-cutting pliers
Scissors
Measuring tape

Twig Techniques

Cutting
Bending
Binding

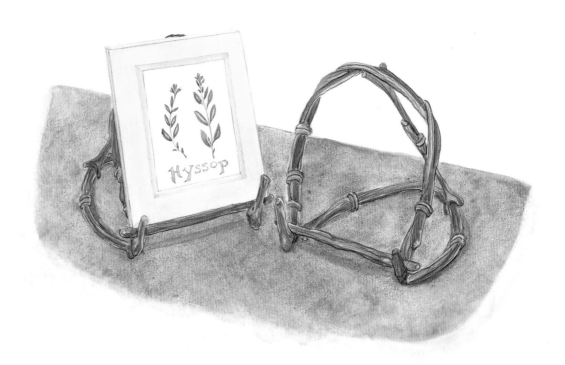

Constructed of scrub oak, the finished dimensions of this project are 8 inches (20 cm) wide by 10 inches (25 cm) high. You can make twiggy easels to hold smaller or larger pictures by adjusting the lengths of the twigs.

1. Place the two twigs with 12-inch (30 cm) forks so the bases are at opposite ends. Bind the two main stem ends, wiring the bases and tips together.

2. Bend the twigs into an arch with your hands. Gently curve the midsection to form an arched structure 7 inches (17.5 cm) wide. The forks should extend behind. Secure the rubber band at the base to hold the arch in place.

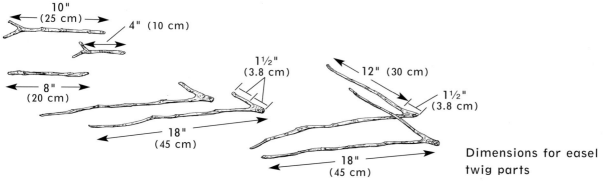

Dimensions for easel twig parts

3. To make the stand, intertwine the extending forks to 6½ inches (16.3 cm) behind the upright arch. Bind with raffia.

4. Bind the 8-inch (20 cm) twig with wire to the base of the arch, where the rubber band is. Cut the rubber band and remove.

5. Bind one of the remaining 18-inch (20 cm) twigs with wire to one side of the base. The fork will be one of the hooks that hold the picture, so keep the hook facing the front. Wind the length of the main stem around the structure and bind the end with wire. Repeat with the remaining long forked twig on the opposite side of the trellis.

6. Hold the two remaining twigs together with the **Y**s at opposite ends. Hold them so that one **Y** hook fits in the top of the easel and slide the twigs apart until the other **Y** hook fits into the far end of the back support. Bind them together with wire.

7. Hook one end of the **Y**s to the top of the easel, and the other end to the back. Cover wire with raffia, if desired. Trim raffia and wire ends. Use shears to even up the base if needed.

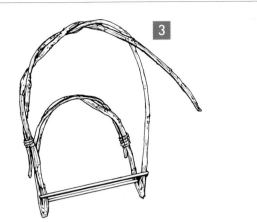

Arch and intertwine the twigs to form the top and back of the easel.

Art imitates nature, and necessity is the mother of invention.

— Richard Franck

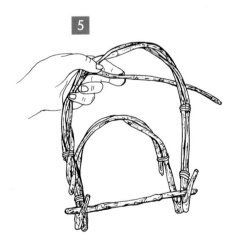

Bind the twigs so that the fork or hook is facing forward, then wind the length around the top of the frame.

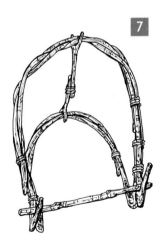

Hook and bind the Y-shaped twigs in place as a support for the frame.

NATURE IN THE NECESSARY ROOM

The inventive use of natural elements softens man-made materials, adds distinctive character, and complements any color scheme. The bathroom, dominated by cold tile and porcelain, is often the least personal room in the house. Ease the harsh quality of the necessary room with the whimsical toothbrush trellis and roll cover, and combine with other twiggy acessories such as the Towel and Basket Tree (page 96) and the Window Screen (page 80).

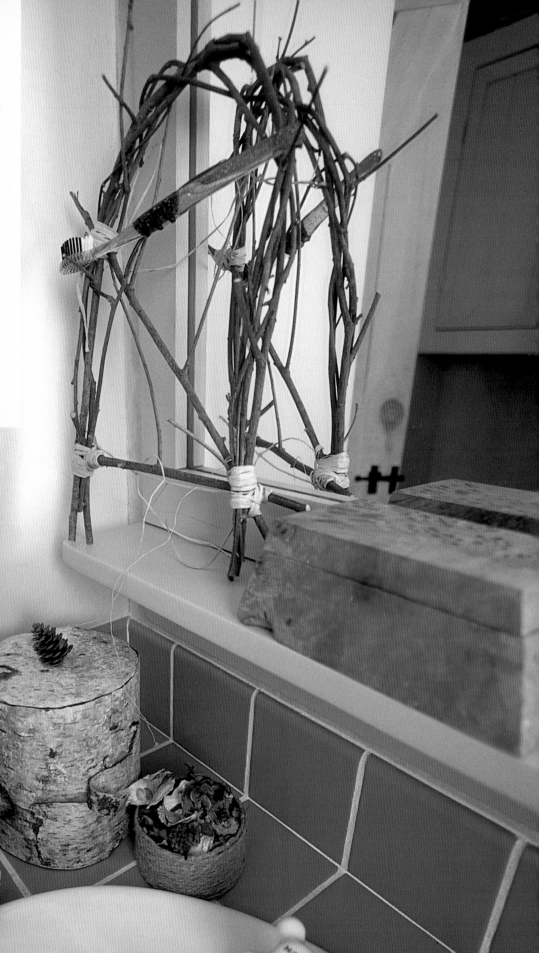

Toothbrush Trellis

Standing at the sink or hung on the wall, the toothbrush trellis adds a whimsical touch to the bathroom. We chose one-year-old growth from an oak stump. The 3-foot (90 cm) shoots were straight and very flexible. Some of the branching twigs were pruned to become the hooks that hold toothbrushes. Try to align the hooks side-by-side, but they will probably twist and shift, making the toothbrushes sit crookedly. We like the way that looks, too.

1. Lay two of the longest twigs side by side with bases and tops at opposite ends. Twist the two stems together and bind the ends. Bend into an arch with your hands, gently curving the midsection, to form an arched trellis 5 inches (12.5 cm) wide. Secure the rubber band on the two legs of the trellis to hold the arch in place.

2. Cross the side branches and bind with wire on the opposite side.

3. Bind the two remaining long twigs to the arched trellis, winding them around the structure. Trim the front facing, upturned forks to 1½ inches (3.8 cm). Any remaining forks can be crisscrossed or wound around the trellis.

4. Cut the rubber band and remove. Use the eight forked twigs, as needed, to provide additional hooks. Pair them opposite one another, lining them up on the trellis. Tuck the ends in between other twigs or bind with wire if necessary to hold hooks in place. Trim any unwanted twigs and even up the base with shears if needed. If desired, bind with raffia to cover the wire.

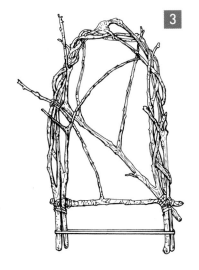

Secure the arched form of the trellis before removing the rubber band.

Materials

Twelve twigs, ¼ inch (.6 cm) in diameter at the base:
- 4 very flexible forked branches, 3' (90 cm)
- 8 forked, 6" (15 cm), fork in the center trimmed to 1½" (3.8 cm)

Twenty-four gauge wire
Rubber band, 3 inches (7.5 cm) long
Raffia (optional)

Tools

Pruning shears
Tape measure
Side-cutting pliers
Scissors

Twig Techniques

Cutting
Bending
Binding

Extra Roll Cover

Materials

Oatmeal box: round, 42-ounce (1.2 kg) size
Masking tape
Birch bark: about 2½ feet (75 cm) square
Wood glue
Paper towels
Weight that will fit inside oatmeal box, such as a heavy vase
Snap clothespins
Ten rubber bands, 4 inches (10 cm) long
Birch branch cross-section for "knob": 1 inch by 1 inch (2.5 by 2.5 cm) of fresh wood (not rotted), or a small pine cone

Tools

Pocketknife
Ruler
Pencil
Serrated knife
Utility knife or scissors

Twig Techniques

Cutting
Gluing

Walking through the woods in October's bright blue weather with leaves crunching underfoot, birds singing their subdued fall songs through the air filled with a cool, woodsy scent made me feel alive with anticipation. I felt an idea coming on as I communed with some of Nature's varied forms. When I came upon a fallen, rotted birch log with its beautiful bark still intact, the idea for this project emerged. Use the Extra Roll Cover to hide that spare roll of toilet paper while displaying the natural beauty of birchbark, or invert it to use as a rustic receptacle (see photo on page 74).

— from Ann

1. Measure 5½ inches (13.8 cm) up from the bottom of the oatmeal box. Mark this measurement around the box with the pencil. Cut along pencil line with serrated knife or utility scissors. Fold lengths of masking tape over and around the cut edge.

2. The bottom of the box will be the top of the roll cover. If the box has a plastic ridge around the top, trim it off with scissors. Apply masking tape to the edge.

3. Place the top of the box on a square of face-up birch bark. Using the box as your guide, draw a circle onto the bark with a pencil. Cut out the circle with the scissors.

4. You'll want to camouflage any holes that occur in the circle of bark. Place the circle on the top of the box. Use the pencil to mark through any holes directly onto the box. Remove the bark and note the size and placement of the marks. Cut patches slightly larger than the marks from a small piece of bark. Glue patches over the marks on the box, pressing firmly.

5. Apply glue generously to the underside of the bark circle. Place it on top of the box, lining it up over the patches, and press firmly. Wipe away any leaking, excess glue with paper towels. Turn the box over and place the weight inside. Let dry overnight.

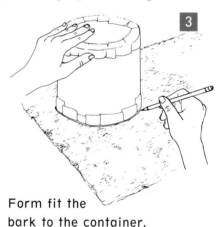

Form fit the bark to the container.

Small bark patches will camouflage holes in the larger bark circle.

6. Carefully tear several strips of bark, approximately 2 inches by 2 inches (5 by 5 cm). The bark will tear unevenly. Apply glue to a strip and place it on the bottom end of the box along the taped edge. Repeat, overlapping the bark, all the way around the bottom. Patch any holes as you go, as described in step 4. As the strips are applied, hold them in place with snap clothespins. The ragged bottom edge will be trimmed later.

7. Tear larger strips and repeat the technique described in step 6, covering the rest of the box. Overlap rows of bark, working your way to the top until the box is covered. Hold glued strips in place with rubber bands, being careful not to glue them to the bark. Let dry overnight.

8. Remove clothespins and rubber bands. Use scissors to trim any ragged bottom and top edges. For the finishing touch, glue a small cross-section of a birchtree limb or a pine cone to the top as a knob.

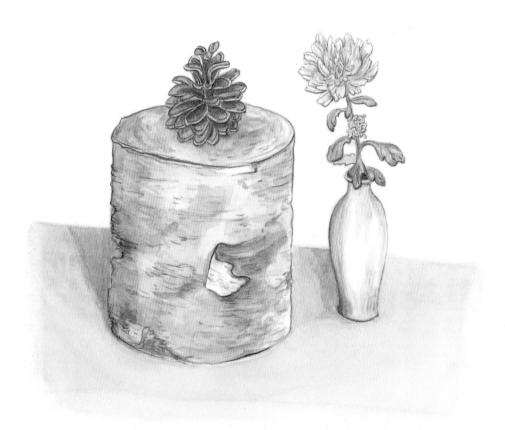

Gathering Bark

Stripping bark from a live tree is difficult and can kill the tree. Instead, look for a fallen birch log that is sufficiently rotted, allowing you to poke a pocket-knife easily through the bark and into the decaying wood. Using your knife, cut the log into 1-foot (30 cm) sections. Hold a section vertically between the palms of your hands and roll it back and forth while pressing firmly. This will cause most of the rotted wood to fall away. Cut a slit along the length of the section with your knife. Open the bark up, lay it on a flat surface, and scrape away the remaining loose pieces with a knife.

You may find sizable pieces of birchbark in sheaths upon the forest floor, shed from live trees. This bark works well, too.

ARTFUL ARRANGING

The most beautiful and expensive furniture, carpets, and accessories are left wanting when framed by blank walls. Even a modestly furnished room, when comfortably surrounded by well-designed walls, exudes warmth and unity. Create a unique wall grouping by combining objects of a pleasing variety of shapes, sizes, textures, and colors to complement the other furnishings in the room. For a truly personal look, choose objects that you like and that have something in common. The twig mirror and shelf, herb tree, root writing, and any of the projects in this chapter can be included in a harmonious wall design with other nature-oriented objects, such as baskets, old-fashioned garden implements, and framed botanicals.

The timeless principles that guide room arranging can be applied to designing wall groupings. One common mistake made with wall treatments is spacing objects too far apart. A successful wall grouping must feel like a unified whole. Just as creative furniture arrangement involves more than lining the pieces around a room, creative wall design is not simply hanging some pictures in the middle of a wall. Artful arranging is a balancing act of creating paths, curves, and angles of space around and between the objects to move the viewer's eye throughout the design. For a stabilized wall composition, consider the visual weight of each object you want to display. Make smaller spaces around small, light-colored, or "lightweight" items. Use slightly more space around larger, darker, or "heavy-weight" items. Stagger both the objects and the space around them with careful placement. Whatever the number and combination of objects you choose, balance is the key to good design.

An easy way to determine your design is to work on the floor. Arrange the objects for your wall grouping until you are satisfied with the composition. Measure the spaces and use chalk to mark the location on the wall for hanging. When arranging many small objects, try cutting out a paper silhouette of each one and rearranging them on the wall until you reach the desired effect. Use low-tack or repositionable tape to avoid damaging the paint or wallpaper.

Hanging objects too high, another common mistake in wall design, separates them from the other room furnishings. Think of designing walls in the same way that living-room seating is orchestrated to invite conversation, and integrate the entire room by bringing the wall grouping down to take part in the discussion.

For low-ceiling rooms, a vertical arrangement will make the walls seem higher. For small rooms, a horizontal arrangement will make the walls seem wider. Start with a focal point to initially draw the eye, such as a colorful work of art or a dramatic but simple espalier cascading along the wall, and build your design around it. Or decorate your windows with the twig shutters, topper and window screen, then gather an artfully arranged group of objects along the window wall to create a focal point for the whole room.

◀ A simple bundle of twigs can represent a whole garden. Sometimes a mere touch strikes a momentous chord.

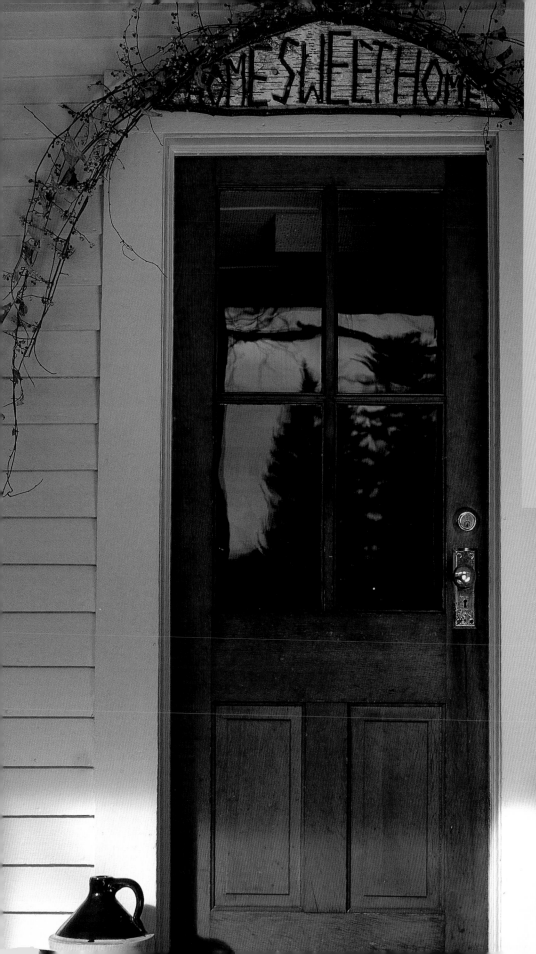

ROOT WRITING
AND TWIG LETTERING

The two styles of lettering described here are achieved according to the materials used: uniform, measured letters made with twigs, and flowing, uneven letters formed with roots and vines. The visual appeal of letters made with roots and twigs and the fun we have making them is so enjoyable that we could make signs for anywhere and for every occasion — words of welcome, words of wisdom, signs designating rooms, naming the gardens, and messages of all kinds. Make some signs that are relevant to you. When making signs for the outdoors use galvanized or stainless steel nails.

Twig Lettering

Materials

Wood board: 6 inches by
 25 inches (15 by 62.5 cm)
Paint or sandpaper
 (optional)
Paper (optional)
Clear adhesive tape
 (optional)
Twigs: ⅛- to ¼-inch
 (.3 to .6 cm) diameter
½-inch (1.3 cm) nails
Brown or gray permanent
 marker
Sawtooth picture hanger

Tools

Measuring tape
Pencil
Pruning shears
Tack hammer

Twig Techniques

Cutting
Bending
Nailing

Maple twigs are gray and fairly smooth; cedar twigs are brown and textured. I chose both to provide some variation in the lettering. While Ann worked on Root Writing (the next project), I searched my basement and found a 6 inch by 25 inch (15 by 62.5 cm) pine board with a rough surface and a few characteristic knots. It seemed long enough for the message I had in mind, but first I designed the letters on paper to be sure they would fit within the space. If you prefer to eliminate measuring, just cut the twigs and shape each letter on a board that seems much longer than necessary. Trim the board to size after your message is completed. For signs that will be hung indoors, gluing the letters works as well as nailing.

Twig shape is an important consideration for making letters. As you can see from the examples, twigs of all shapes and sizes can be coaxed, trimmed, and flexed into the appropriate letter forms. However, it's easiest if you can find twigs that naturally take on the shape of the letters.

— *from Laura*

1. If desired, prepare the board by painting it or sanding any rough edges.

2. It may help to write out the words, full size, as they will appear on the board. (Tape sheets of paper together to re-create the size of the board, if necessary.) Draw a straight line across the paper ¾ inch (1.9 cm) from the bottom. Draw a second line 3½ inches (8.8 cm) from the bottom. Draw a third line at 4¾ inches (11.9 cm) from the bottom. These lines will act as a guide when forming the letters.

3. The letters are all capitals. The first letter of each word is 4 inches (10 cm) high by 2 to 3½ inches (5 to 8.8 cm) wide. The rest of the letters are 3 inches (7.5 cm) high by 1 to 2 inches (2.5 to 5 cm) wide. The sizes are approximate, and as you form the twig letters these sizes will vary somewhat. Don't be too strict with the measurements. Variation adds to the personality of the letters.

4. Start with the first letter and move on from there. Follow the guide you made in step 2, the measurements given in step 3, and the letter formation key on page 59. Choose twigs that are shaped appropriately for the letters. Hold each twig to the guide to determine where to trim it. As you form each letter, leave it in place on the guide so that you can judge letter and word spacing.

5. When complete, nail each twig in its place on the board, following the paper guide. Hammering will cause the twigs that aren't nailed down to scatter, so remove one twig from the guide at a time and nail in place. Use one or two nails per twig.

6. If desired, color the twigs with markers. Center the sawtooth hanger in the back of the board near the top edge and hammer into place.

Lettering Ideas

Think of meaningful words and phrases to make with roots and twigs. For consideration:

Clarity, Harmony, Peace, Simplify, Sunshine, Welcome; "There's always the garden," "Carpe diem," or your favorite quote; names of family members; the seasons; seasonal and holiday greetings; your favorite flowers and herbs.

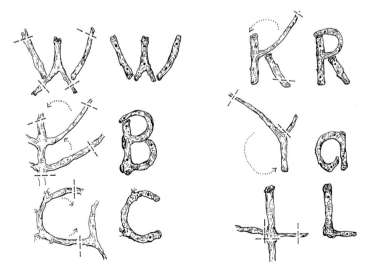

Letters are formed from trimming, coaxing, and arching twigs into a variety of shapes.

Root Writing

To find materials for this project, I went for a walk along the cranberry bog and gathered 2-foot-long (60 cm) briar roots that I found sticking up out of the sand. Holding one of the flexible roots, I bent it into an **S** shape and the word "Simplify" immediately came to mind. Because this word is the very essence of the philosophy of Henry David Thoreau, it holds special significance for me. I found two roots designed by Nature to resemble an M and a Y and these became the most interesting letters. When I finished the sign it didn't seem complete, so I picked a blade of a broad-leafed grass called deer tongue, printed "Thoreau" on it with a fine-line marker, and glued it to the corner of the sign.

Roots and vines are very flexible, easy to work with, and can be found in assorted shapes and configurations. When gathering roots and vines, let your imagination run free in the same way as when seeing shapes and faces in the clouds. For example, briar roots have a jointed, skeletonous quality — a good choice for a *beware* sign! Cedar tree roots have many tiny roots and the smaller roots of many trees often have natural curves. As vines grow and twine around other plants and objects, they form suggestive shapes. New growth is often smooth, becoming slightly shaggy as it matures, providing variety as writing material.

— *from Ann*

Materials

Board: sized to accommodate writing, or trim to size later
Paint or sandpaper (optional)
Roots and/or vines: flexible, some shaped like letters or parts of letters
½-inch (1.3 cm) nails
Measuring tape (optional; use to measure board)
Sawtooth picture hanger

Tools

Pruning shears
Hammer
Small handsaw (if needed to cut board)

Twig Techniques

Cutting
Bending
Nailing

1. If desired, prepare the board by painting it or sanding any rough edges.

2. After deciding upon your word or message, examine the gathered roots and vines to see if any resemble particular letters or parts of letters. Shape and cut each letter, keeping the personality of the materials' natural forms in mind. In other words, make "rooty" or "viney" looking letters.

3. The flexibility of roots and vines makes them easy to shape, but they will spring back to their original form when not held in place. To attach letter shapes to the board, hold the root or vine in place and gently tap a nail through it until the nail head is even with the root or vine surface. Be careful not to damage it. Reshape the letter as needed, tapping in nails as you go.

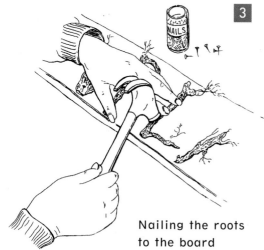

Nailing the roots to the board

4. For roots and vines resembling letter parts, add lengths of root or vine as needed to form the entire letter. Nail in place.

5. Wait until you have completed the sign to determine which, if any, tendrils need trimming. Trim the board to size if necessary. Center the sawtooth hanger in the back of the board near the top edge and hammer into place. If desired, color the twigs with markers.

WALL HANGINGS

The gods do not deduct from man's allotted time the hours spent in twig time.

When you are experiencing twig time, all your cares and worries are forgotten. You are content to be either looking for twigs, making something from twigs, or admiring the twig things you've already made. After making the wall clock, which will help you keep track of twig time, you can merrily move on to the herb tree, rustic rack, and twig mirror and shelf projects.

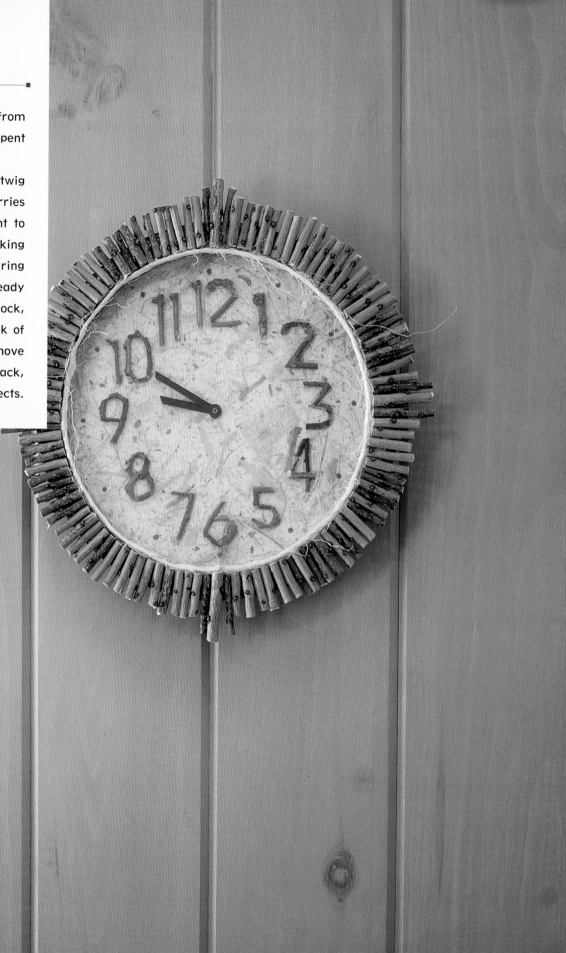

Twig-Time Wall Clock

wig lettering, or should we say numbering, is used to create this project made from an inexpensive, 10-inch (25 cm), black plastic wall clock purchased from a drugstore. My original idea was to simply wrap vines around the frame of an electric clock to form a clock wreath, but Ann suggested the twig-numbered face. When it was finished, we decided against the wreath, so as not to detract from the lovely numbers on the face.

The original clock face had heavy black numbers. When covered with translucent bark paper, similar to the paper used for the candleshade in chapter 2, the numbers showed faintly through the paper — just enough to guide the formation of the cedar and maple twig numbers. Given some patience, you can come up with twig numbers that look remarkably consistent and in scale with one another.

— from Laura

Materials

Wall clock: battery operated, 10 inches (25 cm) wide, heavy black numbers approximately 1¼ inches (3.1 cm) high set on a paper face
Decorative paper, such as translucent bark paper
Spray adhesive
Twigs: small, forked, ⅛- to ¼-inch (.3 to .6 cm) diameter
Wood glue
Twine
Battery (see clock package)

Tools

Screwdriver
Scissors
Pruning shears
Tweezers

Twig Techniques

Cutting
Gluing

1. Remove the plastic covering the clock face. Depending on how it is assembled, unscrew it or carefully pry it off from the back with a flat or slotted screwdriver. Gently lift off the hands. Note the order of the second, minute, and hour hands, and how they are situated. If replaced incorrectly they will not work. Remove the paper clock face.

2. Place the decorative paper over the clock face to be sure the numbers will show through. Apply spray adhesive, following label instructions, to the paper clock face. Lay it face down on the back side of the decorative paper and press to adhere. Use scissors to cut out the circle of the new clock face. Poke through the little center hole where the clock hands will attach.

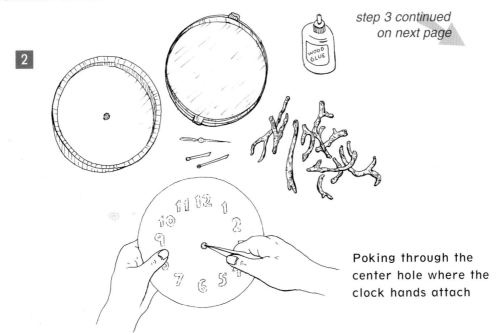

step 3 continued on next page

Poking through the center hole where the clock hands attach

Twig-Time Wall Clock continued

3. Form the numbers from the curves, knots, forks, and straight lines of twigs. Cut twigs to size, using the clock face numbers as a guide. Use tweezers and wood glue to put the twig "puzzle pieces" together, directly over the numbers showing through the decorative paper.

4. If there is a cardboard base behind the paper face of your clock, apply spray adhesive to the back side of paper face. Replace the face inside the clock, adhering it to the cardboard base.

5. If the edge of the clock face circle appears uneven, apply a thin line of glue around the edge of the circle clock face and trim with twine.

6. To reassemble the clock, gently replace the clock hands, setting each one in its correct location. Trim hands with scissors if they overlap the twig numbers. Replace the plastic cover. Install the battery.

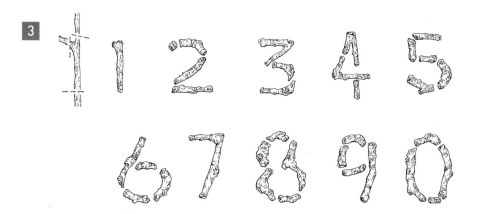

Here you can see the configurations of the numbers made from the curves, knots, forks, and straight sections of tiny twigs. Some of the twig pieces are only ¼ inch (.6 cm) long! Use tweezers for easy handling and placement of twig bits.

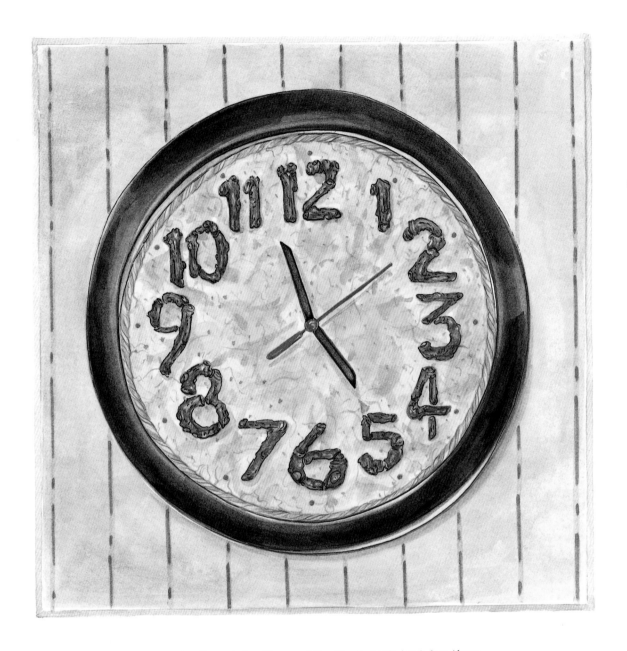

In time take time while time doth last for time
Is no time when time has past.

— Nicholas Stone, accountant to James I,
in an account book displayed at the
Soane Museum (London)

Herb Tree

The bowed crosspieces of this herb tree help the air circulate around bundles of drying herbs. We used red cedar branches that nature had already designed into a curved shape. Hang the shortest herbs or flowers from the top of the tree, and the longest from the bottom. When not used to dry herbs, this project can display ornaments, hanging collectibles, linens and lace, scarves or ties. The finished size is 32 inches (80 cm) high by 24 inches (60 cm) wide at the base, and bows 4 to 6 inches (10 to 15 cm) from the wall. Because of its triangular structure, the Herb Tree holds its shape well using only the binding technique.

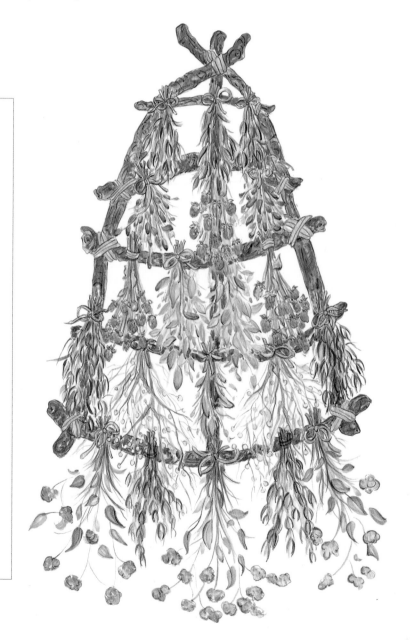

Our Favorite Herbs

The following flowers and herbs are our favorite choices for this project. They dry well by hanging upside down:

Baby's breath	Mint
Boxwood	Oregano
Chive flowers	Rosemary
Everlastings	Sage
Germander	Tansy
Goldenrod	Thyme
Lavender	Yarrow

To air dry: Cut in the late morning after the dew has evaporated. Cut some rubber bands and tie the elastic around small bundles of four to eight stems each. (Rubber bands will secure the bundles even as the herb stems begin to dry and shrink.) Tie bundles to your herb tree with raffia. Hang away from direct sunlight in an airy room. Plants will dry in one to two weeks.

1. Cross two of the longest twigs a few inches from the top of the curved ends. Bind with a doubled 18-inch (45 cm) length of raffia.

2. Lay the 26-inch (65 cm) twig across the base of the herb tree. Lay the rest of the crosspieces in place from the shortest at the top on down. Adjust the angle of the herb tree, if necessary, so that each crosspiece end hangs over the end of the herb tree. This is the front of the herb tree. As you tie on the crosspieces in step 3, make sure each of the crosspieces is bowing toward you.

3. Bind the bottom crosspiece to the herb tree. Wrap raffia from front to back, crisscross in back, bring it to the front again, and tie in a square knot. Repeat for each crosspiece. Don't trim raffia tails yet.

4. Turn the herb tree over so the back is facing you. Lay the last 32-inch (80 cm) twig vertically in the center. Keep all the crosspieces bowed out. Bind the vertical twig to the top and to each bowed twig. This will keep the bowed twigs in position.

5. Cross the raffia once again and bring the tails to the back, tying each pair of tails in a square knot. Trim all raffia tails. Trim the twig ends if necessary. Attach a 12-inch (30 cm) length of wire to the top and twist to form a loop. Hang the herb tree from a nail or picture hook.

Materials
Eight twigs:
- 3 fairly straight, curved at one end, 32" (80 cm)
- 1 bowed, 26" (65 cm)
- 1 bowed, 10" (25 cm)
- 1 bowed, 14" (35 cm)
- 1 bowed, 17" (42.5 cm)
- 1 bowed, 21" (52.5 cm)

Raffia cut in 18-inch (45 cm) lengths
Eighteen gauge wire
Nail or picture hook

Tools
Pruning shears
Scissors
Side-cutting pliers

Twig Techniques
Cutting
Binding

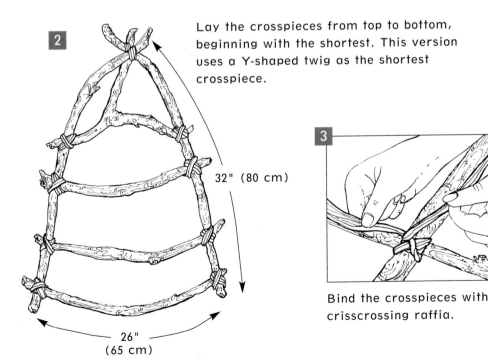

Lay the crosspieces from top to bottom, beginning with the shortest. This version uses a Y-shaped twig as the shortest crosspiece.

32" (80 cm)

26" (65 cm)

Bind the crosspieces with crisscrossing raffia.

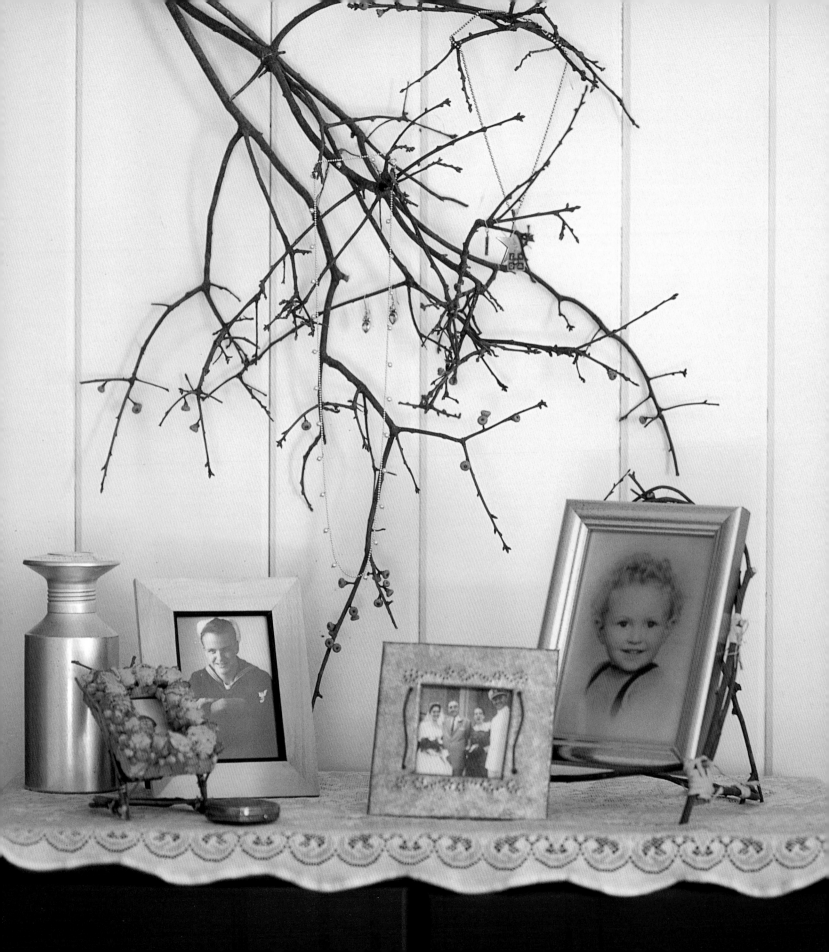

Rustic Rack

Our rustic rack displays decorative necklaces on a bedroom wall when they are not being worn. Choose evenly shaped branches that form a pleasing appearance when held together bouquet style. Branches with developing buds or fruit, generally found in spring or fall, will enhance your rustic rack. We used 30-inch (75 cm) oak branches with developing acorns. If the buds or fruit are fully formed they will drop off or shrivel up, so look for unmatured growth.

1. Cut branches to a size befitting your purpose or wall space. Arrange them in a bouquet. Bind the bases together with wire. Bind the branches together at one or two cross points.

2. Determine the back side. Fold a 15-inch (37.5 cm) piece of wire in half and twist it around itself. Loop the ends around the base of two forked twigs, about one-third of the way down from the top.

3. Hold the rustic rack up to the wall to determine the picture hook location. Trim any twigs protruding from the back. Adjust the wire as necessary so the rack hangs out slightly from the wall, but touches the wall at the base. Nail the base to the wall to secure it in place, if desired.

Materials

Twigs: two or three
 very twiggy branches
Twenty-four gauge wire
Picture hook or nail

Tools

Pruning shears
Side-cutting pliers
Hammer

continued on next page

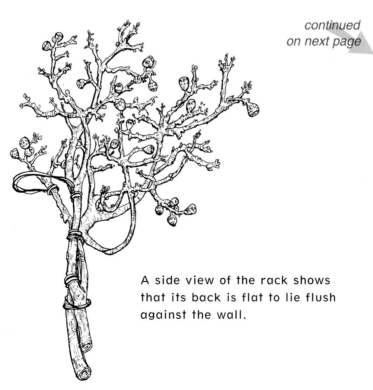

A side view of the rack shows that its back is flat to lie flush against the wall.

Cobweb Catchers

Cobweb catchers are simple, enchanting, and reminiscent of the gray arms of driftwood, shells, and trailing vines that Anne Morrow Lindbergh dragged from the beach to adorn her cottage (see page viii). Long vines of grape, honey-suckle, or wisteria, stripped of leaves and twisted or braided together, can be tacked to a wall as a natural border to frame a doorway or window, or wrapped around a stair rail. Leave just as is or decorate it. String fresh cran-berries and bay leaves, popcorn, seeds, or other natural material with a needle and long lengths of thread. Add strings of mini Christmas lights, especially for festive occasions.

Twig Mirror and Shelf

Our twig mirror is made from sassafras twigs nailed to a 12- by 16-inch (30 by 40 cm) recycled wood frame purchased at a yard sale for fifty cents. If you are using a recycled frame, remove the contents, backing, and hanging hardware. Nailing twigs to square or flat frames is easier than nailing into rounded frames. Purchase a mirror to fit your frame and a framing kit wherever glass is sold.

The shelf can be used to display objects or a trailing plant. Or hang it on the wall near the back door for keeping track of car keys or other necessities.

1. Place the frame on your worktable in a vertical position. Hold a straight twig against the top of the frame. Cut the twig to size. Repeat for the two sides. Nail the three twigs in place.

2. Hold a forked branch to one front bottom corner. Cut to size and nail to frame. Repeat for second forked branch, placing it in the opposite corner and lining it up with the first fork.

3. Hold a straight twig against the bottom of the frame. Cut to fit in between forked branches. Nail to frame.

step 4 continued on next page

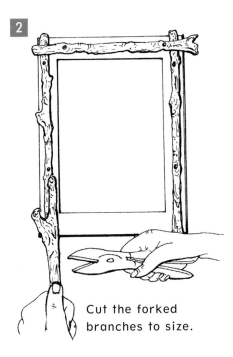

2

Cut the forked branches to size.

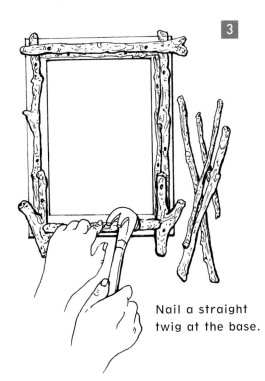

3

Nail a straight twig at the base.

Materials

Picture frame: 12 inches by 16 inches (30 by 40 cm), or whatever you can find (adjust twig lengths to fit)

Twigs:
- about 20 straight, ¼- to ½" (.6 to 1.3 cm) diameter, cut longer than frame dimensions
- several narrow, ⅛" (.3 cm) diameter
- 2 similar forked branches, 4 to 6" long (10–15 cm), ½" (1.3 cm) diameter

½-inch (1.3 cm) and ¾-inch (1.9 cm) nails

Mirror cut to fit frame

Framing kit: contains glazier's points, screw eyes, braided picture wire, hanging hooks

Wood glue

Brown kraft paper, larger than the picture frame

Vine with tendrils, 5 feet (1.5 m) long (optional)

Tools

Pruning shears
Hammer
Measuring tape
Flat screwdriver
Utility knife

Twig Techniques

Cutting
Nailing
Gluing

4. Measure and cut additional twigs as needed to cover the front of the frame. Nail in place as you go. Narrow twigs can be glued in between the larger nailed twigs to fill in any gaps. Keep the twigs from going over the inside of the frame lip. The mirror will be inserted through the back of the frame, and will need to fit flush against this lip.

5. Turn the frame over, letting the forked branches on the bottom rest over the edge of your table. Insert the mirror. Attach with glazier's points, pushing them into the frame with the flat end of the screwdriver.

6. Apply glue to the back of the frame. Lay the brown kraft paper over the glue and press all around frame. Trim the edges with a utility knife. Attach screw eyes and wire.

7. Set the frame to face front in a vertical position. Cut notches close together into the forked branches. Apply glue to the notches, trim the remaining twigs to size, and arrange them across the forked branches to form the shelf.

8. Wind the vine around the outside of the frame and tack in place, if desired. Your twig mirror and shelf is ready to hang!

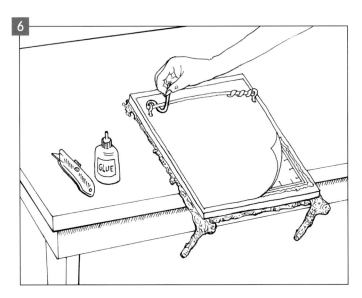

Attach the screw eyes and wire over the brown paper backing.

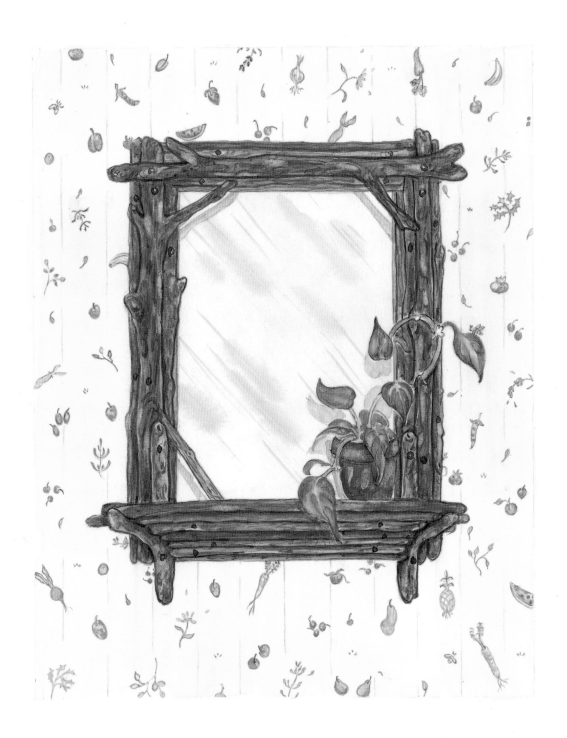

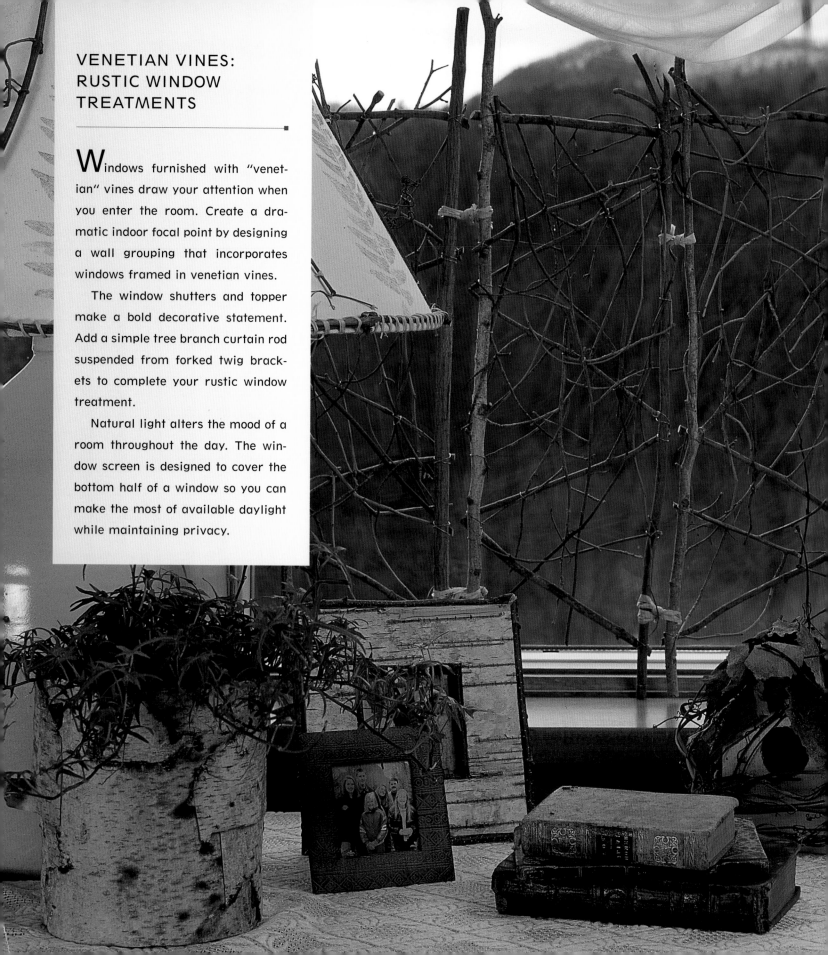

VENETIAN VINES: RUSTIC WINDOW TREATMENTS

Windows furnished with "venetian" vines draw your attention when you enter the room. Create a dramatic indoor focal point by designing a wall grouping that incorporates windows framed in venetian vines.

The window shutters and topper make a bold decorative statement. Add a simple tree branch curtain rod suspended from forked twig brackets to complete your rustic window treatment.

Natural light alters the mood of a room throughout the day. The window screen is designed to cover the bottom half of a window so you can make the most of available daylight while maintaining privacy.

Window Shutters

The instructions given here are for two shutters made to fit a 45-inch (1.1 m) high window. Measure your window(s) and adjust the twig dimensions to fit. This project is made from oak, sassafras, and cedar twigs and branches and embellished with honeysuckle vines. When laid against a straightedge, the branches deviate here and there. But end to end, each one remains on an even keel.

1. Work on the floor or outside on the ground. It will be easier to create a matched pair if you work on both shutters at the same time. Lay the four longest twigs on the floor about 9 inches (22.5 cm) apart. Arrange them so they will lay flat. The two straightest twigs should be on the outside, as these will be lined up next to the window moldings. You will be working on the back sides of the shutters; the fronts are facing the floor.

2. Remove any branching forks that keep the twigs from laying flat. Decide which, if any, branching forks to keep as crosspieces.

3. Choose four of the 1-foot (30 cm) long twigs. Place them at the two top and bottom ends of the shutters. Trim ends to hang only 1 inch (2.5 cm) over the sides. For all four end pieces: Draw next to both sides of top twig with pencil to mark bottom twigs. Remove top twig and cut notches at pencil lines. Apply glue to notches and replace top twig. Nail the eight notched joints and bind with wire. Twist the bound wire at the back (the side of the shutters facing you).

step 4 continued on next page

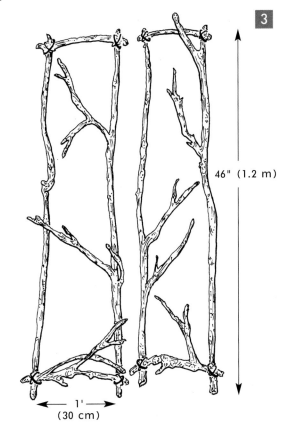

3

46" (1.2 m)

1' (30 cm)

Nail and bind the eight notched joints to form two rectangles.

Materials

Thirty-six twigs:
- 4 relatively straight, ½" (1.3 cm) diameter, 46" (1.2 m) long
- 8 straight, ½" (1.3 cm) diameter, 1' (30 cm) long; do not trim branching twigs
- 2 straight, ¼ to ½" (.6 to 1.3 cm) diameter, 2' (60 cm) long
- 2 flexible, ¼" (.6 cm) diameter, 2' (60 cm) long
- 18 straight, 18" (45 cm)

Wood glue

½-inch (1.3 cm) and ¾-inch (1.9 cm) nails

Twenty-four gauge wire

Vines: 40 feet (12 m), approximately ⅛- to ¼-inch (.3 to .6 cm) diameter (can be in several pieces)

Tools

Measuring tape
Pruning shears
Pencil
Ruler
Tack hammer
Side-cutting pliers

Twig Techniques

Cutting
Notching
Gluing
Nailing
Binding
Bending

Window Shutters continued

4. Measure 21 inches (52.5 cm) and 29 inches (72.5 cm) up from the bottom on both sides of each shutter. Mark the measured points with a pencil. Place the foot-long (30 cm) twigs on the marks as crosspieces. Mark and cut a notch at each intersection and apply glue. Place the crosspieces in the notches. Bind the joints with wire. Trim crosspieces as in step 3.

5. Branching forks remaining from step 2 can be crossed over and nailed or bound in place.

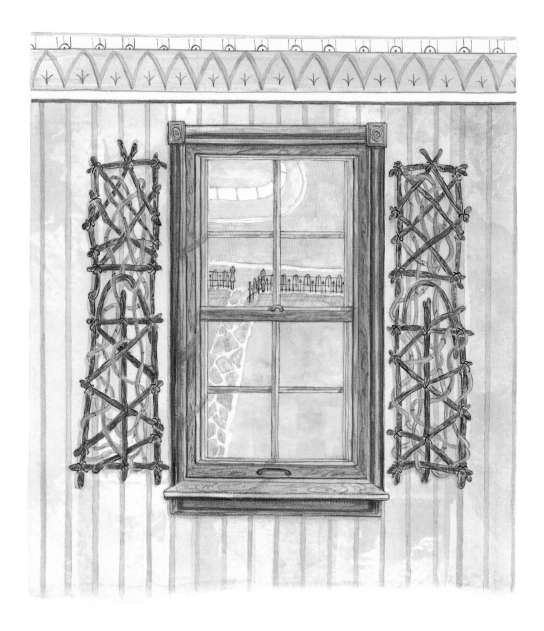

6. Center the 2-foot-long (60 cm) straight twigs on the two bottom and middle crosspieces. Nail or bind in place. Bend the 2-foot-long (60 cm) flexible twig between the middle crosspieces and nail or bind in place.

7. Make a crisscross pattern on the top and bottom sections with some or all of the 18-inch (45 cm) twigs. Trim them to size as needed. Notch, glue, and nail a few of them for added stability to the structure. Bind the rest with wire.

8. Weave the vines over and under the crisscrossed twigs throughout. Trim any twig ends or vines as desired.

9. Hold one shutter in place next to the window. Nail in two or three spots where the side twigs lay flat against the wall, or attach to window molding. Repeat with the other shutter.

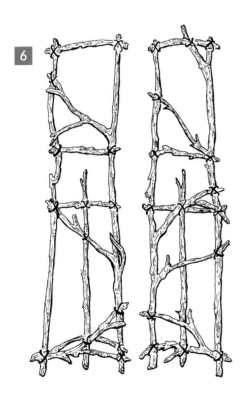

Center the 2-foot-long (60 cm) straight twigs on the bottom and middle crosspieces.

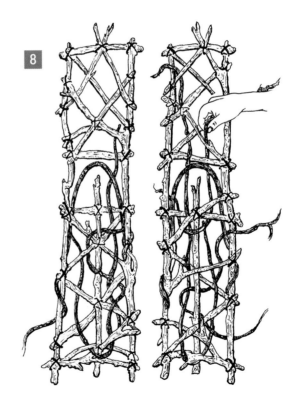

Weave the vines throughout the shutters.

Window Topper

The topper is made to fit above the top molding of the window. It can sit on top of the molding above the window, or be nailed to the wall directly above it. Measure the length of the molding above your window and cut your base twig to this size. Cut as many lengths of flexible twigs as needed for the arches. Our base twig is cedar with five flexible huckleberry shoots for the arches. The topper described here is 22½ inches (56.3 m) wide and made for the same window as the shutters, described above.

Nature is a mutable cloud which is always and never the same.

— Ralph Waldo Emerson

1. Slowly roll the longest twig along a table to see in which position it will sit the flattest. Mark the top for reference.

2. Lay this twig on the table with the top facing away and bottom facing toward you. Locate the center of the twig and measure four inches in both directions. Mark these two points with a pencil. These points mark the ends of the middle arch, which will be 8 inches (20 cm) wide.

3. Place one end of a flexible twig at one pencil mark, perpendicular to the base twig. Nail in place. Bend twig into an arch and repeat with the other end.

4. Place the end of a second flexible twig one inch to the inside of the middle arch. Nail in place. Bend twig into an arch, 6 inches (15 cm) high and 5 inches (12.5 cm) wide. Nail in place. Repeat on the opposite side of the middle arch.

5. Make the final, smallest arch 4 inches (10 cm) high and 4 inches (10 cm) wide in the same manner as above.

6. Bind each nailed joint with wire and trim the ends of the arches. Cross the two remaining twigs at the center and bind in place.

Materials
Eight twigs:
- 1 straight, ½" (1.3 cm) diameter, 22½" (56.3 cm) long
- 5 flexible, ¼" (.6 cm) diameter, 22" (55 cm) long
- 2 straight, forked at one end, ⅛ to ¼" (.3 to .6 cm) diameter, 12" (30 cm) long

Twenty-four gauge wire
½-inch (1.3 cm) nails

Tools
Pencil
Measuring tape
Pruning shears
Tack hammer
Side-cutting pliers

Twig Techniques
Cutting
Nailing
Binding

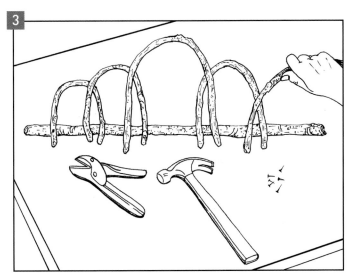

Bend the twigs into a series of arches.

Window Screen

The window screen is designed to sit on a windowsill covering the bottom half of the window. To determine the width of the three panels, measure the width of the window and divide by three. This birch, maple, and cedar screen was made for an 18-inch-wide (45 cm) window with a 3½-inch (8.8 cm) sill. Each of the screen panels is 6 inches wide. The finished size is 18 inches (45 cm) wide by 23 inches (57.5 cm) high. For use as a privacy screen add a lot of twiggy embellishment or weave many vines until you can't see through the panels, although the screen looks very pretty with some sunshine coming through.

This project also makes a delightful doll-sized folding screen (see page 112).

1. Lay the six 23-inch (57.5 cm) twigs next to each other in pairs of two, 6 inches (15 cm) apart. The four straightest twigs should be on the inside. They will be wired together for folding.

2. Place one of the 8-inch (20 cm) twigs across each pair, 5 inches (12.5 cm) down from the top. Trim to size so that the crosspieces overlap the long twigs only slightly. Cut notches in the long twigs where they cross. Apply glue and replace crosspieces. Nail in place.

3. Place three more crosspieces at a diagonal along the bottom, keeping each panel 6 inches (15 cm) wide. Trim crosspieces to size, cut notches, apply glue, and nail in place, as above. Continue the diagonal pattern along the middle of each pair with remaining crosspieces, using three more for each panel. Nail or bind in place.

step 4 continued on next page

Materials

Thirty-three twigs:
- 6 relatively straight, ½" (1.3 cm) diameter, 23" (57.5 cm) long
- 15 straight, ¼" (.6 cm) diameter, 8" (20 cm) long
- 12 narrow, flexible, branching, up to 20" (50 cm)

Wood glue
½-inch (1.3 cm) nails
Twenty-four gauge and eighteen gauge wire
Vines (optional)

Tools

Pruning shears
Measuring tape
Tack hammer
Side-cutting pliers

Twig Techniques

Cutting
Notching
Gluing
Nailing
Binding

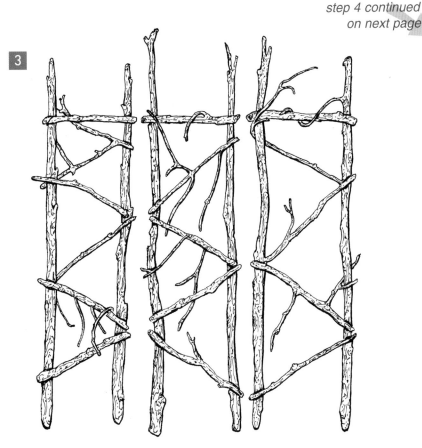

Place diagonal crosspieces to create a zigzag pattern.

4. Weave the flexible, branching twigs or vines throughout. Bind as needed with twenty-four gauge wire.

5. Using a 7-inch (17.5 cm) piece of eighteen gauge wire, make a loop around the side twig of the center panel and twist to close. Loop wire around adjacent panel's side twig and twist. The loops can fit a little loosely. Repeat, looping wire three more times to connect each side panel at two junctures to the center panel. Trim ends and twigs as needed.

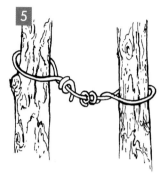

Twist together wire loops to connect the panels.

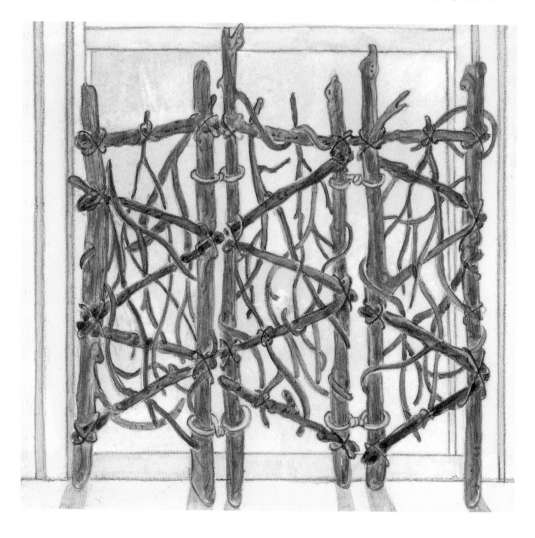

Rustic Rods

The brackets and the rustic rod complement each other perfectly. Cut a tree branch at least 8 inches longer than the width of your window. All shapes make beautiful rods — straight, curved, or gnarly, depending on the look you want. Place the rod in the brackets and trim to desired size. Trim branching twigs to hang a curtain or valence. Tab curtains, a swag, or a window scarf wound around the rod work best. Try a valence of vines loosely arranged around the rod, or suspend ornaments or paper cutouts tied to ribbon or raffia. Nailed to a wall, brackets and rods also make great racks for towels, linens, or quilts.

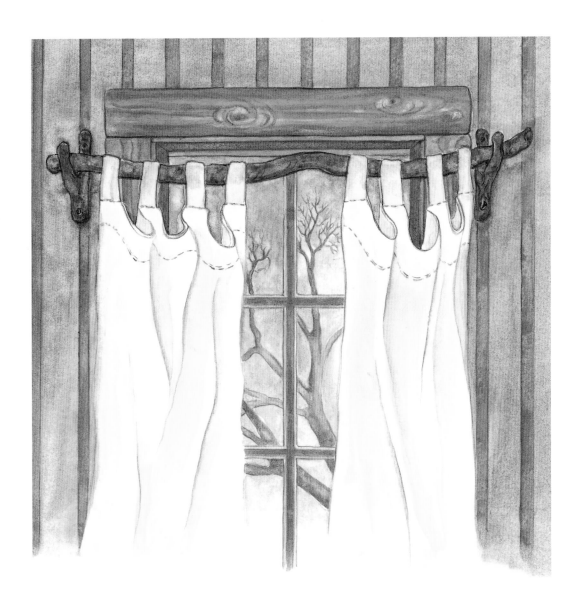

Brackets

A matched pair of 5-inch (12.5 cm) brackets will hold a curtain rod branch. We used hickory, but any sturdy forked branches at least ½ inch (1.3 cm) in diameter will do.

The brackets can be made in all sizes and shapes for a variety of uses, wherever you need a hook. Hang brackets with tree branch rods in the bathroom or kitchen as towel racks, or make a wall display of your quilts or linens. Nail a row of bracket hooks to a board, making a rack for coats, hats, towels, umbrellas, or toys. Use little hooks for hanging mugs, kitchen utensils, keys, or jewelry.

An alternative to brackets is to suspend the rod with wire: Cut two 9-inch (22.5 cm) lengths of wire. Make a 1-inch (2.5 cm) loop in one end of each wire. Hammer two 1-inch nails into the top of the window frame, a few inches in from the end of the molding. Slip one loop over each nail. Raise rod up and loop one wire around it, twisting loosely. Level the other end of the rod; loop and twist the second wire loosely. Check that the rod is hanging level, or as desired. Twist wire ends tightly to secure. Tie on curtain tabs, or decorate rod as desired.

Materials

Twigs: two matching forked branches, ½-inch (1.3 cm) diameter
Nails: four 1-inch (2.5 cm) finishing nails

Tools

Pruning shears
Measuring tape
Claw hammer

Twig Techniques

Cutting
Nailing

1. Find the first forked branch and cut so that the first branch stem is 5 inches (12.5 cm) long, with 2 inches (5 cm) below the fork and 3 inches (7.5 cm) above the fork. Trim the fork to 3 inches (7.5 cm). Use this bracket as a guide, holding it against other forked branches to find a similar one; trim the second fork to the same dimensions as the first.

2. Hang the brackets at the top or middle of the window, wherever you want the curtain to be. Nail to the window molding or wall, ½ inch (1.3 cm) from the top of the bracket and ½ inch (1.3 cm) from the bottom

3. Hang a rustic rod (see page 83) inside the forks.

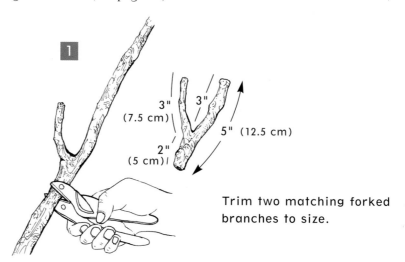

3" (7.5 cm) 3"

5" (12.5 cm)

2" (5 cm)

Trim two matching forked branches to size.

Really, Really Rustic Rods

Exhibit the natural beauty of a leafy branch. Cut an oak branch at least 6 inches (15 cm) longer than the width of your window. Before bringing it into your house, hose off the leaves to remove insects. Shake off excess water and let the branch dry in the shade. When dry, hang it in brackets or suspend it from wire above existing window treatments. The leaves will remain fresh for a day or two. Really, really rustic rods add a special feeling to a room when decorating for a festive occasion. Hang one over every window. Evergreen boughs will last longer and are great at holiday time. During cold winter months, insects shouldn't be a problem, so evergreens don't need to be hosed with water. The evergreen branch shown here is suspended from wire, as described on page 84.

NATURAL DECORATING

Linking different styles of furnishings, accessories, lighting fixtures, and other decorating components requires a willingness to experiment and, sometimes, a sense of humor. Adding rough-hewn furnishings to your decor is an exciting, creative outlet for your imagination.

The twig furnishings in this chapter are versatile projects. The sisal settle could be equally at home as the footrest for a contemporary chair or as the seat for a charming secretary's desk. The open air partition would grace a country porch or frame an elegant settee. Twig things can complement your existing furnishings for a naturally pleasing, eclectically styled home.

PRESENTATION IS EVERYTHING

Artful decorating isn't determined by which objects we choose, but how those objects are presented. The common denominator between a crystal candy dish and a twiggy easel is that we like them both.

Unifying factors such as judicious color choices and a good sense of scale will harmonize the most eclectic room. Choose colors for the walls, ceiling, and floor that will unite the colors of the major furnishings. Plan arrangements with consideration to scale and balance. Just as the key to exquisite flower arrangements is color, scale, and balance, so it is with room arranging.

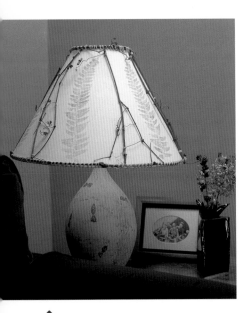

Rustic accents can "brighten" any room.

DECORATING STYLES WITH BRANCHES, TWIGS, AND VINES

Decorating styles are named after

- furniture designers, such as Chippendale or Hepplewhite
- the time period of an age, as Renaissance or Modern
- the monarch who ruled at that time period, as in Edwardian or Victorian
- the country of origin of a particular style, such as Spanish or English
- popular concepts, such as Minimalism or Surrealism

Then there are "twig things," named for the material from which they are made! You can find a name to fit your eclectic style whether you like contemporary or Queen Anne, American colonial or Southwest, French country, Scandinavian rustic, art deco, neoclassic, or any combination of diverse decors. We have named five styles to choose from, or make up one of your own to best describe your altered surroundings as twig things begin to add their special charm to your home decor.

Traditional Twig mixes with conventional, period furnishings.
Twig Deco is a free-spirited look with twentieth-century materials and trends.
Twig Naturale is fresh, comfortable with American or European country style.
International Twig blends with a specific national look, such as Japanese.
Twigism offers rustic rooms furnished predominantly with twig things.

Winter and Summer Looks

In the winter we bring out cozy afghans, decorate with evergreens and warm red candles, turn up the heat, and keep wood stacked near the fireplace. In the summer, we turn to outdoor living, and often neglect the inside. Twig things can look snug and inviting in the wintertime, and fresh and airy in the summer in accordance with their surroundings. Refresh the indoors during hot weather with some simple, naturally cooling tips:

- Cover throw pillows, diaper or envelope fashion, with crisp muslin

- Put away heavy drapes in favor of lightweight gauze panels

- Roll up dark rugs and scatter some sisal mats or canvas floor cloths

- Display white candles and bowls of fresh fruit

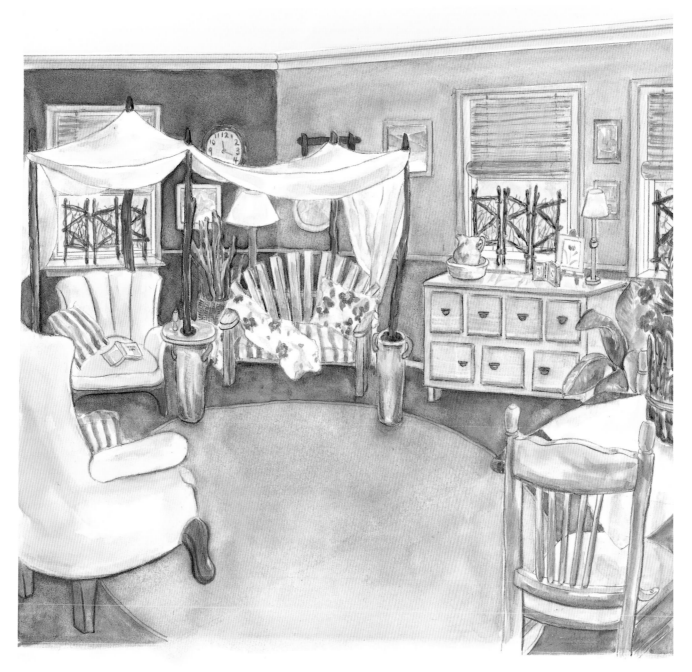

"Twig Naturale" is fresh,
comfortable with American
or European country style.

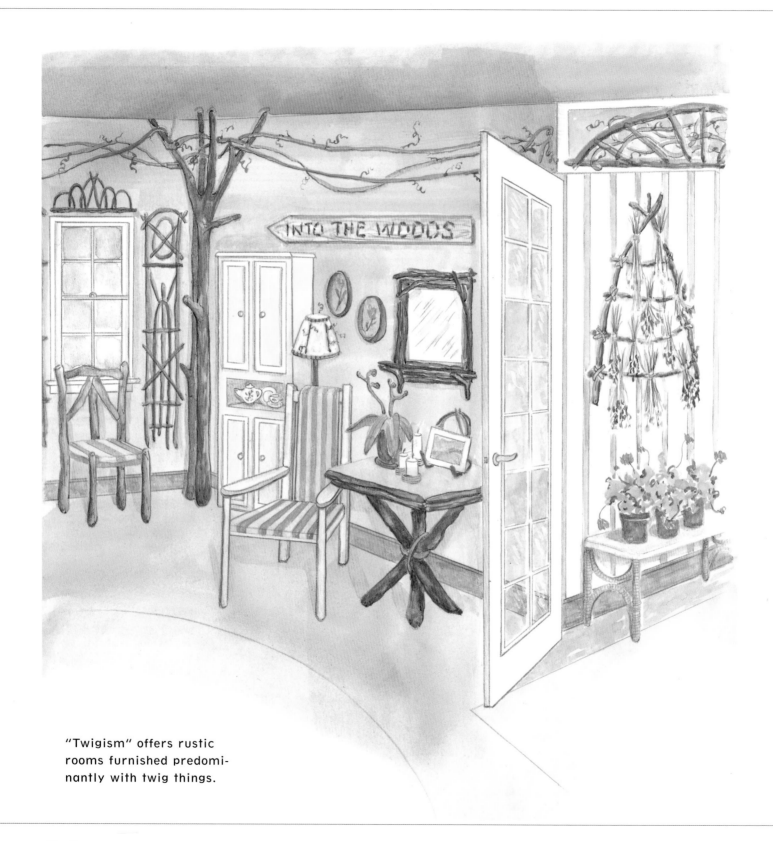

"Twigism" offers rustic rooms furnished predominantly with twig things.

Open Air Partition

The openness of this decorative folding screen allows light and air to circulate, and creates a barrier without obstructing the view. Use it as a room divider, or as a place to display lacy linens or a straw hat collection. Place it against a wall as a backdrop for a cozy seating area or a plant grouping.

To create a privacy screen, add more crosspieces and weave vines in between, or display linens or embroidered tablecloths over the crosspieces in each panel. Turn a corner of a bedroom into a dressing alcove or hidden storage space. Placing the privacy screen in front of sliding glass doors will let the air in, and keep your privacy in too.

The finished size (ours is about 6 feet [1.8 m] high and 5½ feet [1.7 m] wide) can easily be lengthened by adding additional panels. We used oak and cedar saplings, branches, and twigs. Work on the floor or outdoors on the ground. You can work on one panel at a time on a large picnic table, but we preferred working on all three at once in order to match up the crosspieces.

1. Place the two tallest saplings on the floor or ground, 22 inches (55 cm) apart. They will form the center panel. Lay the other four saplings to form two side panels, one on either side of the center panel, 2 to 3 inches (5 to 7.5 cm) from the outer edges of the center panel. The side panels should be 17 inches (42.5 cm) wide, with the shortest saplings placed at the outer edges. Make sure the bases of the saplings are aligned.

2. Keep in mind that the back of the partition is facing you; the front is lying on your work surface. Working on one panel at a time, cross forking branches as desired and nail to opposite side. Trim forking branches as needed.

step 3 continued
on page 93

Materials

Twenty-one twigs (leave any forking branches):
- 6 relatively straight saplings, 1½ to 2" (3.8 to 5 cm) in diameter, ranging from 58 to 75" (1.5 to 1.9 m) high
- 15 in a mix of forked, straight, and curved, ¼ to ¾" (.6 to 1.9 cm) diameter, about 30" (75 cm) long

Wood glue
¾-inch (1.9 cm) and 1-inch (2.5 cm) nails
Eighteen gauge and twenty-four gauge wire
Vines (for a privacy screen, optional)

Tools

Measuring tape
Small handsaw
Lopping shears
Pencil
Pruning shears
Claw hammer

Twig Techniques

Cutting
Notching
Gluing
Nailing
Binding

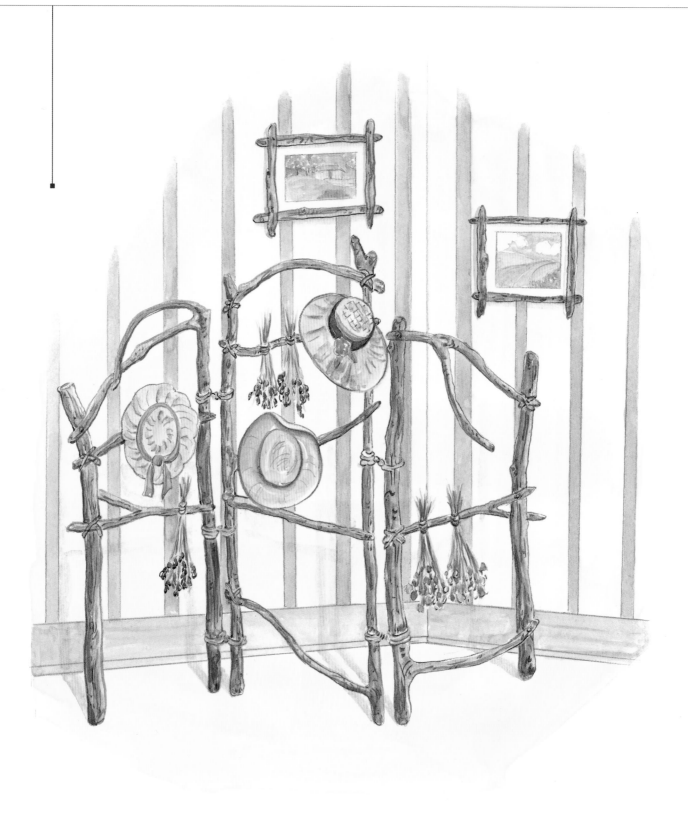

3. Choose three curved, 30-inch (75 cm) crosspieces. Arrange them across the top of each panel. Mark the saplings where the branches intersect, cut notches with pruning shears, apply glue, and nail in place. Trim crosspieces as needed.

4. Arrange the additional crosspieces, lining them up as desired across the three panels. Notch, glue, and nail in place. Trim as needed.

5. In addition to nailing, use twenty-four gauge wire to bind two or three of the crosspieces in each panel for added stability. Twist the wire bindings at the back (the side facing up).

6. Locate six points where the saplings in each pair come closest together near the top, middle, and bottom of the panels. Using the eighteen gauge wire, make a double loop around a sapling on the center panel and twist to secure. Make a double loop around the adjacent sapling and twist to secure. Loop fit can be a little loose. Repeat at each of the other five points. (See page 82 for a similar example.)

7. Place the partition in an upright position. Adjust the panels in a zigzag so they will be freestanding. Trim saplings at the base with lopping shears or saw to even the partition if necessary. If the panels resist folding, the crosspieces may be butting against each other — trim their ends.

For a privacy screen: Add more vines and crosspieces; or neatly drape a collection of linens or embroidered tablecloths over each panel.

Glue and nail the forking and top crosspieces in place.

3

← 17" → ← 22" → ← 17" →
(42.5 cm) (55 cm) (42.5 cm)

Birchwood Forest Headboard

This birch headboard will fit a single (42-inch, or 1-meter) bed. It can lean against a wall, or be attached to a wall with screws. You can make a headboard to fit any size bed by adjusting the measurements to fit. Work on the floor or outdoors on a large picnic table. We worked out of the tailgate of Ann's truck.

Originally, we intended to trim a lot of the branches, but then decided we liked the twigginess too much. Weave one or two strings of tiny Christmas or party lights in the twigs. At bedtime, the effect is like seeing stars through the tree tops!

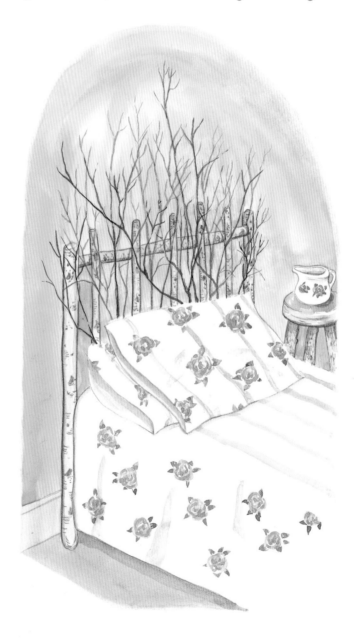

1. The 42½-inch-long (1 m) limbs are the vertical bedposts. Measure and mark with a pencil at 1½ inches (3.8 cm) and 3 inches (7.5 cm) from the top of each post.

2. Measure and mark at 20 inches (50 cm) and 21½ inches (53.8 cm) up from the bottom of each post.

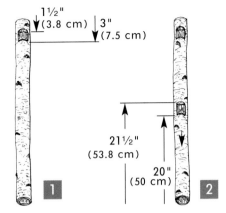

3. Saw ¼ inch (.6 cm) into each mark. Score through the bark with the utility knife to the ends of each cut on both sides. Use the chisel to pry out the notches and to scrape away any remaining rough wood.

4. Apply glue to the notches. Place the ends of the 1½-inch-wide (3.8 cm) crosspiece in the notches at the top of the post. Nail in place through the post and into the end of the crosspiece with the 3-inch (7.5 cm) nails. Place the ends of the 2-inch-wide (5 cm) crosspiece in the bottom notches and nail in place through the post and into the end of the crosspiece with the two remaining 3-inch (7.5 cm) nails.

5. Lay the twiggy branches in place vertically, creating the "birchwood forest." Nail each branch to the top and bottom crosspieces. Trim the bottom ends of the twiggy branches to even them. Trim the twigs as desired.

6. Lean the bedstead against the wall and place the bed in front of it. Attach the headboard to the wall with screws, if desired.

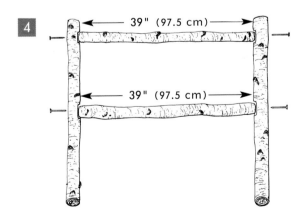

Materials

10 branches or saplings:
- 2 fairly straight birch limbs, 1½" (3.8 cm) in diameter at the base, 42½" (1 m) long
- 1 fairly straight birch limb, 1½" (3.8 cm) in diameter, 39" (97.5 cm) long
- 1 fairly straight birch limb, 2" (5 cm) in diameter, 39" (97.5 cm) long
- 6 very twiggy birch branches, ½ to 1" (1.3 to 2.5 cm) in diameter, 36" (90 cm) long

Wood glue

1½-inch (3.8 cm) nails and four 3-inch (7.5 cm) nails

3-inch (7.5 cm) screws (optional)

Tools

Measuring tape
Pencil
Small handsaw
Utility knife
Chisel
Claw hammer
Pruning shears
Screwdriver (optional)

Twig Techniques

Cutting
Notching
Gluing
Nailing

Towel and Basket Tree

Materials

Section from a live tree, 1½ inches (3.8 cm) in diameter at the base, cut slightly taller than the height of your room

Nonskid, heavy-duty floor saver (those rubber things for placing under furniture legs)

Tools

Measuring tape
Small handsaw
Pruning shears
Stepladder

Twig Techniques

Cutting

The branches of our towel and basket tree hold bathroom towels and baskets containing soaps, washcloths, and other items. This really big twig can also serve as a coat and hat rack, garden tool hanger, kitchen accessory storage or a place to hang whatever is cluttering up a room.

A sapling may not have enough height or sturdy branches. Choose a substantial specimen and cut the top portion to fit the height needed for your room. We made our version of this project from the upper portion of a young hickory tree.

1. Measure the height from floor to ceiling where you will locate your towel tree. Cut the tree to room height. Trim branches as desired; ours range from 4 to 12 inches (10 to 30 cm) long. If space allows, longer, sturdy branches will hold folded towels or linens.

2. Place the base of the tree in the floor saver at the desired location. Stand on a stepladder, if necessary, to slightly bend the top of the tree as you bring it up to a vertical position. Wedge in place against the ceiling. Trim more off the top if necessary. If you trim too much (oops!) use a clear plastic floor saver at the top.

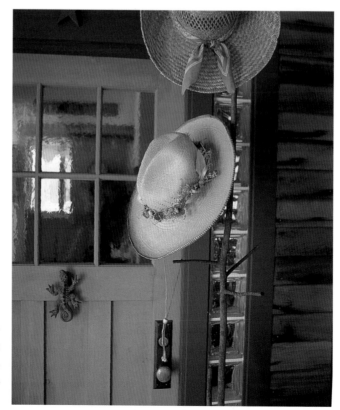

▶ The Towel and Basket Tree can also be used to hold coats, ties, kitchen accessories, hats — whatever you need it for!

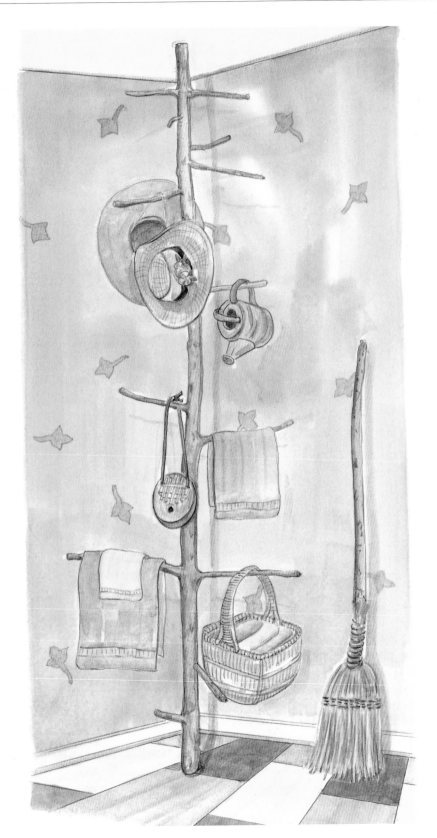

Imaginative Mantel

This purely decorative mantel can be the focal point of a room. Made with highbush blueberry (or huckleberry) branches, favored for their unique, gnarled branching habit, the finished dimensions are approximately 4 feet (1.2 m) wide by 4 feet 9 inches (1.4 m) high. Lean it against a wall or attach it to the wall with screws. Hang a mirror or create a wall grouping above it. Frame it with two overstuffed chairs for a cozy chat corner. Place it under a wall-mounted shelf, and even hang your Christmas stockings from it. Just please don't build a fire in it!

The imagination
is the great friend
of the unknown.
Endlessly, it evokes
and releases the power
of possibility.

— John O'Donohue,
Anam Cara

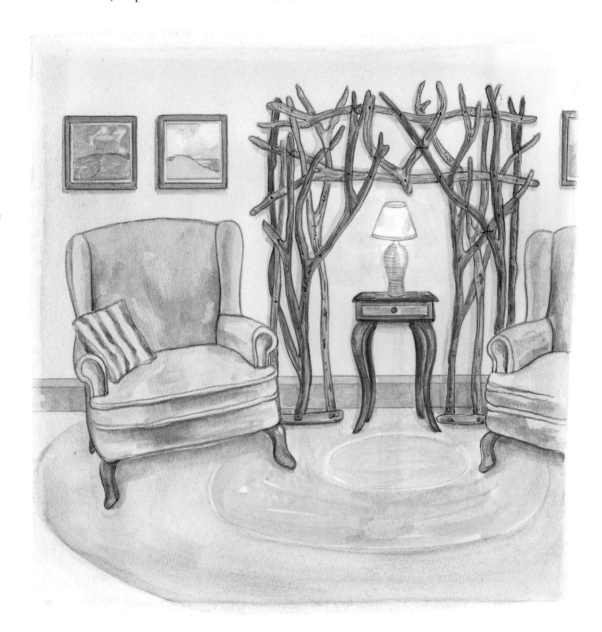

1. Place two of the 5-foot (1.5 m) branches on the floor about 28 inches (70 cm) apart. Place the other two 5-foot (1.5 m) branches next to them, about 10 inches (25 cm) to the outer side of each one.

2. Lay a 4-foot (1.2 m) branch across the top of the assembled branches and nail in place with 1½-inch nails. Place the other 4-foot (1.2 m) branch about 10 inches (25 cm) below the top one and nail in place. This is the basic mantel frame.

3. Lay two of the many-forked branches vertically, each 9 inches (22.5 cm) inside the mantel frame, and nail or bind with wire.

4. Use the additional many-forked branches to fill in the sides of the mantel frame as desired. Nail or bind with wire. Branches may extend over the edges of the frame.

5. The bottom ends may need to be trimmed to level the mantel. Stand it up against a wall and trim as needed with a saw or lopping shears.

6. To stabilize the mantel, nail a 10-inch (25 cm) twig at the base of each "pair" of 5-foot (1.5 m) branches.

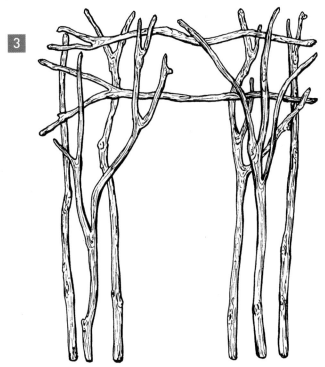

The more forks your branches have, the "wilder" your mantel will seem.

Materials

Fourteen branches:
- 4 fairly straight, forked, 1¼" (3.1 cm) in diameter at base, 5' (1.5 m) long
- 2 fairly straight, forked or straight, 1" (2.5 cm) in diameter at base, 4' (1.2 m) long
- about 6 shaped as desired, many forks, ½ to 1" (1.3 to 2.5 cm) in diameter, about 5' (1.5 m) long
- 2 fairly straight, ¾" (1.9 cm) in diameter, 10" (25 cm) long

1½-inch (3.8 cm), 1-inch (2.5 cm), and ½-inch (1.3 cm) finishing nails
Twenty-four gauge wire

Tools

Measuring tape
Claw hammer
Small handsaw or lopping shears
Pruning shears

Twig Techniques

Cutting
Nailing
Binding

Twine Wrapping

This wrapping technique works for tubular metal furnishings and other rounded shapes, such as cylinder or ginger jar lamp bases. We recycled a slightly bent and rusty metal rod vanity seat, saving it from the trash.

After removing all the screws, we washed each section, straightened two bent rods, and re-covered the seat with remnant fabric, stapling it to the underside. The rods were wrapped with two-and-a-half balls of jute twine, each about 140 feet (42 meters). The twine is held in place with occasional dabs of resin glue formulated for wood and metal. Hot glue also works well. The seat wasn't replaced until the twine wrapping was complete. Our project transcended its original form: from a white and gold, tubular metal vanity seat it became a naturally textured, tawny-colored "sisal settle."

We inadvertently tested the staying power of this technique. Forgetting that the sisal settle was in the open bed of Ann's pickup truck, we drove a few hundred miles through a rain and ice storm! It thawed and dried out the next day, coming through the ordeal intact.

Tips for twine wrapping:

- Buy more twine than you think you will need.
- Begin at the bottom and work up.
- Keep twine taught while wrapping, but not so tight that the twine is being stretched and your fingers hurt.
- Use "butterflies" of twine for ease in handling — trying to wrap and maintain taughtness while holding an entire ball of twine can be difficult.
- Use glue sparingly and in small dabs.

- Secure twine-wrapped sections in place with snap clothespins when stopping to take a break or while working on a different section.
- Apply glue to metal, not to twine.
- To begin each length of twine, place one end in glue and wrap two times around, covering the starting point while holding the end in place.
- End each length of twine by gluing in place.

Other Ideas

Twine wrapping can be used on just about anything you can think of. If the look appeals to you, consider the following as possible candidates:

- Tubular metal furniture
- Lamp bases
- Legs of tables
- Legs, back, and arms of kitchen chairs
- Exposed pipes (plumbing)
- And much more!

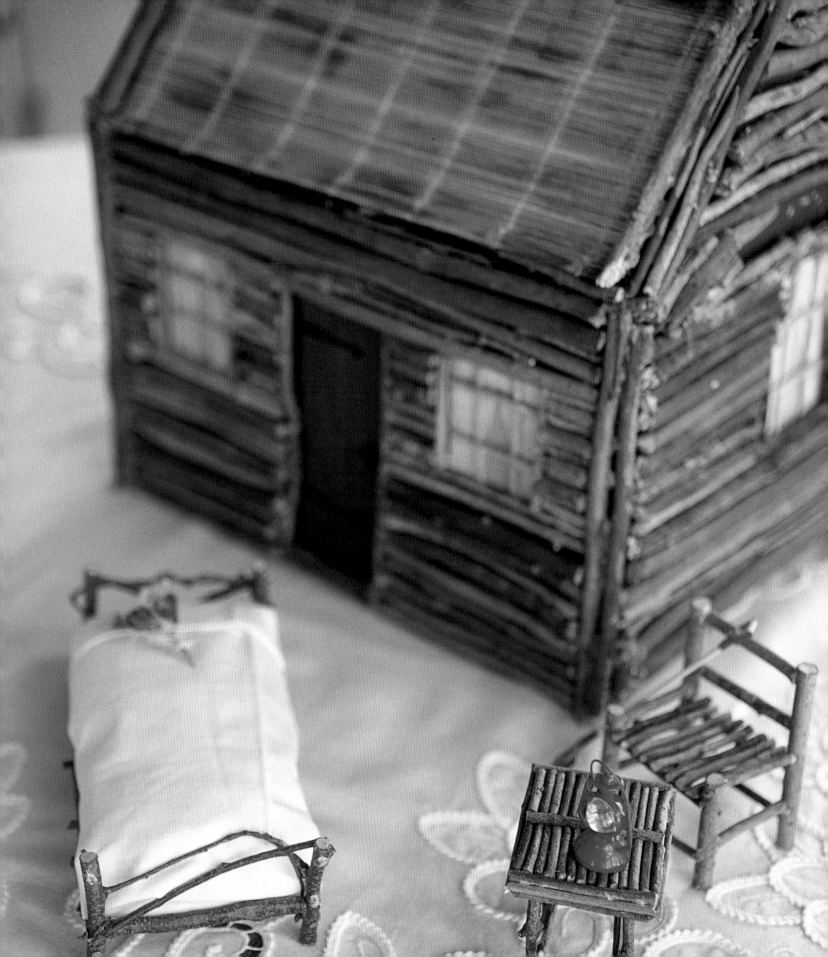

LITTLE LOGS

Be it a weakness, it deserves some praise, We love the play-place of our early days.

—William Cowper,
Tirocinium

As children, both of us made dollhouses and furniture from cardboard boxes, paint, and whatever fabric scraps we could find. And what child doesn't delight in transforming the giant carton from a new washing machine or refrigerator into a house, submarine, or cave? Making houses of cardboard, twigs, or paper with my own children and watching them play house and dress-up conjures distinct childhood feelings.

During playtime children create a separate world for themselves, making it whatever they want it to be. As a rehearsal for adulthood, play is an important learning time for children. As an outlet for creativity and imagination, it is important for both children and adults. Many adults claim to have lost that innate creative response of childhood. But reflecting on Ann's and my continued fondness for making houses, it seems that childhood memories can summon up creative readiness.

MINIATURES

Not just a children's game, collecting and constructing miniatures holds a fascination for many adult hobbyists. The log cabin dollhouse and furniture projects are properly scaled for accessories that can be handmade or purchased in a hobby or specialty store, such as linens, dishes, baskets of food, tiny books and candles, and just about anything else you can think of. In addition to making wonderful toys for your children and their dolls and stuffed animals, the furniture designed for eighteen-inch (45 cm) dolls can be an enchanting display for dolls in your own collection.

Log Cabin Dollhouse

This project is a lot of fun to make. Transforming a cardboard box into the shape of a house is simple. Most of your time will be spent measuring, cutting, and gluing on the twig logs, although this whole project is not nearly as time-consuming as the expensive, premeasured, precut dollhouse kits you can purchase.

Our cabin is made of cedar twigs and the finished size is 16¼ inches (40.6 cm) high at the chimney, by 14½ inches (36.3 cm) wide by 12 inches (30 cm) deep. This size or a similar size will accommodate 1 inch to 1 foot scaled miniature dolls and furnishings. If using a different size box, adjust all measurements.

The dollhouse can be finished inside by measuring and marking the inside walls to correspond with the windows and door. Paint and decorate them as they appear on the outside. Decorate the interior walls with more twigs or use paint or wallpaper.

Gathering "Logs"

If the twigs are roughly 24 inches (60 cm) long, you'll need approximately forty. Set aside straightest twigs for framing the cabin.

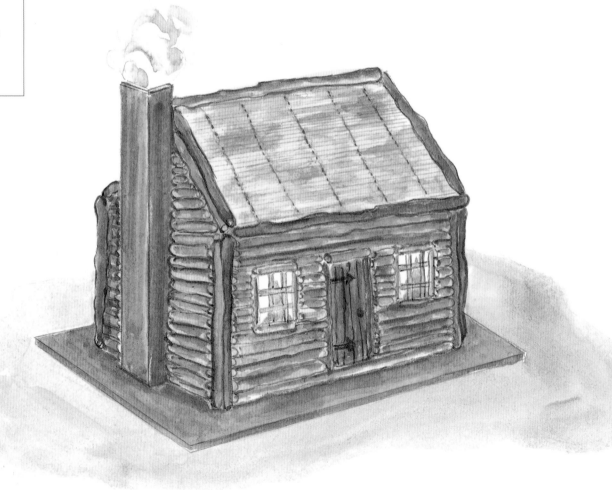

1. Measure 8½ inches (21.3 cm) up from each bottom corner of the box. Cut down from each top corner to that mark with the utility knife.

2. On the inside of the box, connect measured points with the ruler and draw a pencil line across the two long sides. Score along both lines with the blunt end of a utility knife, *blade retracted.*

3. Push along the scored lines, folding flaps inward to form the roof peak. Tape together to hold in place.

4. Trace inside of the flattened side flaps with a pencil, marking along roof peak on both sides of the roof. Cut along these lines with a knife.

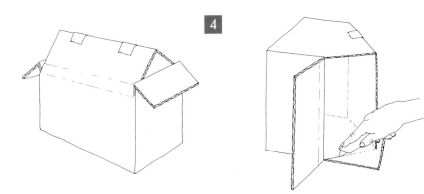

5. Secure the sides of the cabin to slanting roof with masking tape. Remove tape from roof peak. Cut down both corners of one long side for total access to the inside. Cut off the top flap of that side and tape securely to reform the roof peak. The back wall opens out for added play space and can be closed when not in use.

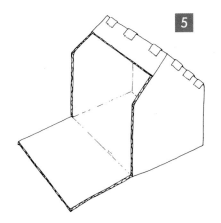

step 6 continued on next page

Materials

Cardboard box: 11¾ inches (29.4 cm) deep, 13 inches (32.5 cm) wide, 11¼ inches (28.1 cm) high
Three cardboard pieces:
- 1 14" x 16" (35 x 40 cm)
- 1 5⅞" x 16" (14.7 x 40 cm)
- 1 large enough for a cutting and working surface

Twigs: should be relatively straight, varying from ³⁄₁₆ inch (.5 cm) to ⅜ inch (.9 cm) in diameter
Masking tape
Acrylic craft paints: brown (optional), sky blue, burgundy red, white, pine green
Matchstick-style placemat
Wood glue
Cotton ball
Twine: 32 inches (80 cm)
Glue sticks if using glue gun
Paper towels

Tools

Ruler
Pencil
Utility knife
Paint brush, flat
Mini paint roller (optional)
Black marking pen, fine tip
Scissors
Pruning shears
Glue gun (optional)

Twig Techniques

Cutting
Gluing

6. For the side window use a ruler to locate the top of window by marking 7½ inches (18.8 cm) up from the bottom of the cabin. Mark 4 inches (10 cm) up from the bottom for the bottom of the window. Measure side to side and locate the center at 5⅞ inches (14.7 cm). Mark 1¼ inches (3.1 cm) from each side of the center line for the 2½-inch-wide (6.3 cm) window. Locate door and front windows in the same manner, following measurements as shown.

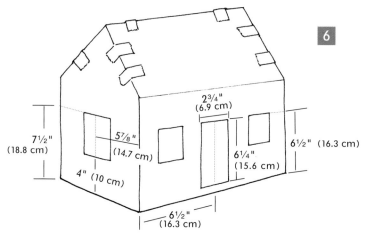

7. For the chimney, measure and draw pencil lines at 1 inch (2.5 cm), 3 inches (7.5 cm), and 4 inches (10 cm) on the 5⅞ inch by 16 inch (14.7 by 40 cm) piece of cardboard. Score along the lines with the blunt end of a utility knife, *blade retracted.* Fold to form a rectangle and tape together.

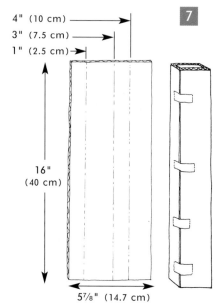

8. If the box has printing on it, paint the cabin brown with a brush or miniroller to make an even, dark background. Let dry. Paint the windows sky blue, the door burgundy red, and paint a two-inch (5 cm) border around the entire edge of the cabin base (the 14 by 16 inch, or 35 by 40 cm, cardboard) pine green. Let dry.

9. For the roof, paint the placemat sparingly, using the dry brush technique: Dip the paintbrush in brown paint. Wipe off the excess paint on a paper towel. Using a light touch, make sweeping strokes across the surface of the placemat, applying uneven, mottled color.

10. Draw a curtain outline with pencil over each dry, sky blue window. Using white paint and the dry brush technique described in step 9, paint a thin wisp of white to form sheer curtains.

11. Using a pencil, draw simple cross-and-arrow shaped door hardware. Draw broken, vertical lines to show door boards. Go over pencil lines with a black marking pen.

12. Glue the chimney at the center of the side wall without a window.

13. Measure and cut four pieces of twine with scissors to create window panes. Glue them in place.

14. Trim the painted placemat to 12 inches by 14 inches (30 by 35 cm), which allows for 1 inch (2.5 cm) of overlap to fold under the back side of the roof. Glue in place.

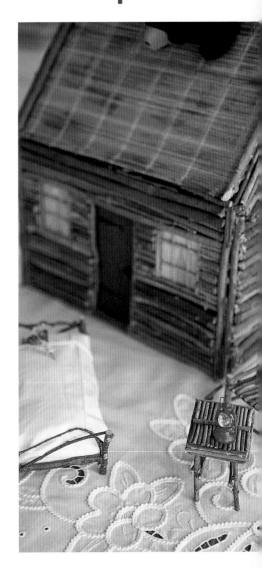

15. Measure, cut, and glue straight twigs (about ³⁄₁₆-inch, or .5 cm, diameter) to frame the windows and door.

16. Measure and cut straight twigs, ³⁄₈ to ½ inch (.9 to 1.3 cm) in diameter, to frame all corners and edges of the cabin. Glue in place. The easiest way to measure a twig "log" is to hold a twig up to the place where it will go and cut it on the spot with pruning shears. When needing several twigs of the same size, measure the first one in this manner and then use it as the measuring standard for the rest.

Note: Hot glue initially holds fast and may be easier to use for attaching framing twigs at corners. Wood glue holds longer. To use wood glue, turn the cabin so that the side to be glued faces up. Apply glue to twig, set in place, hold for a few moments, then continue with next twig. Each side must be completely dry before turning the cabin to glue another side.

17. Measure, cut, and glue twig "logs," filling in between frames. Work from the bottom up.

18. Apply some glue to the unpainted area of the cabin base, center the log cabin on the base, and let dry. For the finishing touch, gently pull the cotton ball apart until it appears loose and flimsy, creating billowy "smoke." Insert it into the top of the chimney.

Lilliputian Log Furniture

The table, chair, and bed are designed to accompany the dollhouse project or any 1 inch to 1 foot (2.5 to 30 cm) scaled dollhouse. We used maple, but any straight, freshly cut twigs will do. You can make whimsical "fairy" furniture by gluing small fragments of small dried plants, flowers, and vines around the edges of the finished furniture.

Constructing small objects with such little twigs somehow requires more patience than working on larger projects, but the Lilliputian results are delightful.

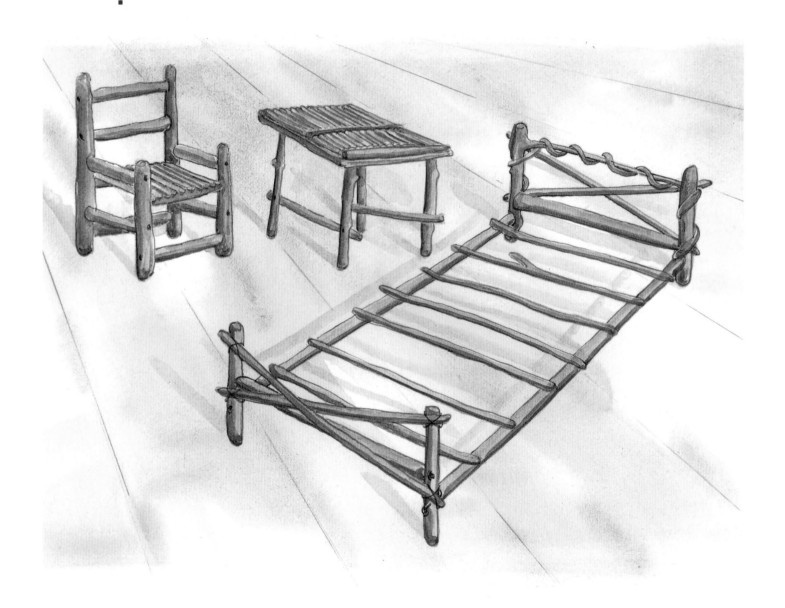

Lilliputian Table

This table is designed to be a side or end table for the Lilliputian Chair (see page 110). However, you can easily make a dining set by enlarging the top to 3 by 3½ inches (7.5 by 8.8 cm) and adding extra chairs.

1. To create the table top, use the ⅛-inch-diameter (.3 cm) twigs. Apply wood glue to one side of the cardboard tabletop and place a 2-inch (5 cm) twig in the center. Lay 1-inch (2.5 cm) twigs along the tabletop on both sides of the center twig, using as many as needed. Place a 2-inch (5 cm) twig at each end of the tabletop. Cover the corrugated edges by gluing the remaining 2-inch (5 cm) twigs, and then the 2¾-inch (6.9 cm) twigs. Let dry.

2. Turn the tabletop over. Apply wood glue all around the edges of the cardboard. Using ¼-inch-diameter (.6 cm) twigs, place 2-inch (5 cm) twigs and two of the 2½-inch (6.3 cm) twigs as shown. Let dry.

3. Squeeze a blob of resin glue in each corner. Set the remaining four 2½-inch (6.3 cm) twigs vertically in place for table legs. Resin-glue the four ½-inch (1.3 cm) twigs in each corner up against each leg. If necessary, hold the legs upright for a couple of minutes until set. Let dry.

4. Glue the remaining 2½-inch (6.3 cm) twigs near the base of the legs with resin glue. Let dry.

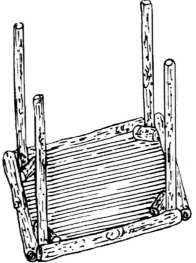

Sticky resin glue and corner braces help hold the legs in place. Let dry in an upturned position.

Materials

Corrugated cardboard:
 2 inch by 2½ inch (5 by 6.3 cm) rectangle
Twigs (relatively straight):
 ■ 5 ⅛" (.3 cm) diameter, 2" (5 cm) long
 ■ approximately 30 ⅛" (.3 cm) diameter, 1" (2.5 cm) long
 ■ 2 ⅛" (.3 cm) diameter, 2¾" (6.9 cm) long
 ■ 6 ¼" (.6 cm) diameter, 2½" (6.3 cm) long
 ■ 2 ¼" (.6 cm) diameter, 2" (5 cm) long
 ■ 4 ¼" (.6 cm) diameter, ½" (1.3 cm) long
 ■ 2 ⅛" (.3 cm) diameter, 2½" (6.3 cm) long
Wood glue
Resin wood glue

Tools

Pruning shears
Ruler

Twig Techniques

Cutting
Gluing

Lilliputian Chair

Materials

Twigs (relatively straight):
- 2 ¼" (.6 cm) diameter, 2¼" (5.6 cm) long
- 6 ¼" (.6 cm) diameter, 2" (5 cm) long
- 2 ¼" (.6 cm) diameter, 3½" (8.8 cm) long
- 4 ¼" (.6 cm) diameter, 1½" (3.8 cm)long
- 8 ⅛" (.3 cm) diameter, 2¼" (5.6 cm) long

½-inch (1.3 cm) nails
Wood glue

Tools

Pruning shears
Pencil
Ruler
Tack hammer

Twig Techniques

Cutting
Nailing
Gluing

This chair can be elongated to make a settee: Use six 3½-inch (8.8 cm) twigs instead of the six 2-inch (5 cm) twigs, and increase the number of ⅛-inch (.3 cm) diameter twigs to sixteen.

1. Using ¼-inch (.6 cm) diameter twigs, take a pencil and mark both 2¼-inch (5.6 cm) twigs at ½ inch (1.3 cm) and at 1⅜ inches (3.4 cm) from the base end. Set two of the 2-inch (5 cm) twigs between the larger twigs at the marks and nail them place.

2. Use the pencil to mark both 3½-inch (8.8 cm) twigs at ½ inch (1.3 cm), 1⅜ inches (3.4 cm), 2¼ inches (5.6 cm), and 3¼ inches (8.1 cm) from the base end. Set four of the 2-inch (5 cm) twigs between these twigs at the marks and nail them in place.

3. Mark both the chair front and chair back: Measuring up from the base, mark each of the four legs at ¾ inch (1.9 cm) and at 1⅞ inches (4.7 cm). Line up the four 1½-inch (3.8 cm) twigs at the marks and nail in place to create the sides of the chair.

4. To form the seat: Glue along the front and back rungs and set the ⅛-inch-diameter (.3 cm) twigs in place. Let dry.

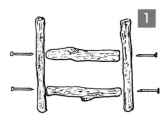

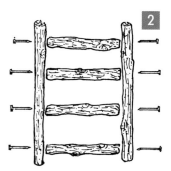

Measure and nail first the front legs and rungs (top), then the back legs and rungs (bottom).

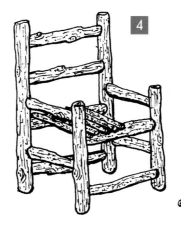

Glue small twigs to form the seat.

Lilliputian Bed

The little doll that sleeps in this bed will be more comfortable if you fold a piece of flannel into a small mattress.

1. Use the pencil to mark the 2½-inch (6.3 cm) twigs at ¾ inch (1.9 cm) and 2 inches (5 cm) up from the base ends. Match them up in pairs, then line up the 3-inch (7.5 cm) twigs between them at the marks and nail in place, forming the head and foot of the bed.

2. Mark the same four 2½-inch (6.3 cm) twigs at ½ inch (1.3 cm), just below the ¾ inch (1.9 cm) mark. Nail the 7-inch (17.5 cm) twigs in place to form the frame.

3. Glue the 4-inch (10 cm) twigs to the head and foot of the bed, crisscross fashion. Let dry. Evenly space the 3¾-inch (9.4 cm) twigs and glue in place to form the slats.

Materials

Twigs (relatively straight):
- 4 ¼" (.6 cm) diameter, 2½" (6.3 cm) long
- 2 ¼" (.6 cm) diameter, 3" (7.5 cm) long
- 2 ¼" (.6 cm) diameter, 7" (17.5 cm) long
- 4 ⅛" (.3 cm) diameter, 4" (10 cm) long
- 10 ⅛" (.3 cm) diameter, 3¾" (9.4 cm) long

½-inch (1.3 cm) nails
Wood glue

Tools

Pruning shears
Ruler
Pencil
Tack hammer

Twig Techniques

Cutting
Nailing
Gluing

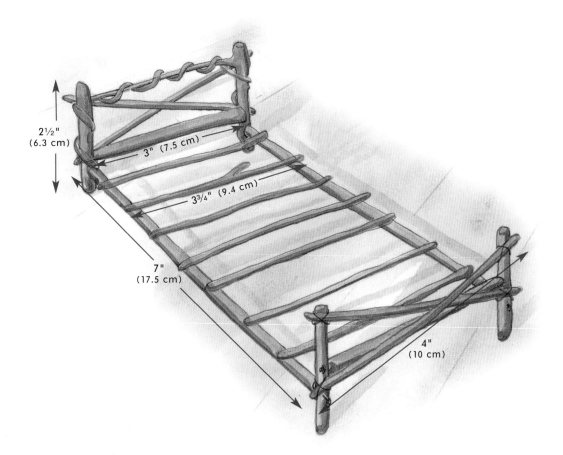

2½" (6.3 cm)

3" (7.5 cm)

3¾" (9.4 cm)

7" (17.5 cm)

4" (10 cm)

Twiggy Furniture for 18-Inch Dolls

Designing this 18-inch (45 cm) doll furniture took me back to my childhood days when I made doll chairs and tables from cardboard boxes. You can make a table and set of chairs from the following instructions. Also, see the venetian vines window screen, described on page 80, which would make a lovely doll-sized folding screen.

We used sassafras and oak twigs. The finished size for the chair is about 11 inches (27.5 cm) high by 6 inches (15 cm) wide and 6 inches (15 cm) deep. The table is 10 inches (25 cm) by 15 inches (37.5 cm), and 10 inches (25 cm) high.

Twiggy Table

Set out a nice "tea" for your doll friends on this rustic table. Or, if you make the sofa variation of the Twiggy Chair, shorten the length of the table legs to make a complementary coffee table.

1. Form a rectangle using the two 9-inch (22.5 cm) and the two 12-inch (30 cm) twigs. Hammer 1-inch (2.5 cm) nails through the side of the 9-inch (22.5 cm) twigs into the cut ends of the 12-inch (30 cm) twigs. This forms the table top frame.

2. Lay an 18-inch (45 cm) twig diagonally, from corner to corner, across the rectangle. Nail in place with ¾-inch (1.9 cm) nails. Trim ends with shears, allowing a ¾-inch (1.9 cm) overhang on each end. Lay another 18-inch (45 cm) twig next to the first, nail in place, and trim. Continue to the corner. As you approach the corner and need shorter twigs, use the pieces that you just trimmed. Go back to the center and work your way to the opposite corner.

3. Lay a 9½-inch (23.8 cm) twig on a hard surface with one end projecting an inch over the edge. Hammer a 1¼-inch (3.1 cm) nail completely through it, ½ inch (1.3 cm) from the end. Repeat for the three remaining 9½-inch (23.8 cm) twigs. These will be the table legs.

4. Stand the tabletop on end, place a leg in one corner on the underside of the table and drive in the nail. Hammer another nail through the leg into the other side of the corner. Repeat for the three remaining table legs.

5. Measure 3 inches (7.5 cm) up from the bottom of two diagonally opposite table legs and mark with a pencil. Position a 13¼-inch (33.1 cm) twig at the marks and nail. Place the other 13¼-inch (33.1 cm) twig diagonally atop the first one and nail to the corresponding legs.

6. Bind the intersection of the diagonal crosspieces with twine. Trim the table legs, if necessary, to level.

Materials

Twigs (relatively straight):
- 2 ½" (1.3 cm) diameter, 9" (22.5 cm) long
- 2 ½" (1.3 cm) diameter, 12" (30 cm) long
- 20 ⅜" (.9 cm) diameter, 18" (45 cm) long (these will be cut to size)
- 4 ¾" (1.9 cm) diameter, 9½" (23.8 cm) long
- 2 ½" (1.3 cm) diameter, 13¼" (33.1 cm) long

1¼-inch (3.1 cm), 1-inch (2.5 cm), and ¾-inch (1.9 cm) nails

Twine

Tools

Small handsaw or lopping shears
Pruning shears
Tack hammer
Measuring tape
Pencil

Twig Techniques

Cutting
Nailing
Binding

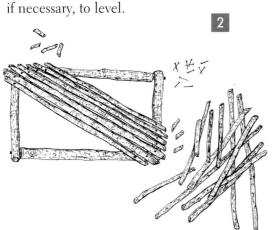

Nail the twigs diagonally to form the tabletop.

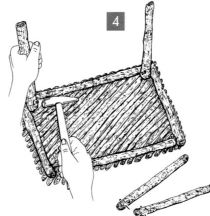

Turn the table upside down to nail the legs to the frame.

Twiggy Chair

Once you've mastered this rustic chair, make one for all of your dolls (and your teddy bears, too). The basic design can be altered to make a sofa by doubling the measurements of the horizontal twigs.

Materials

Thirty-three twigs (relatively straight):
- 2 ½" (1.3 cm) diameter, 6½" (16.3 cm) long
- 9 ⅜" (.9 cm) diameter, 5" (12.5 cm) long
- 2 ½" (1.3 cm) diameter, 11" (27.5 cm) long
- 6 ¼" (.6 cm) diameter, 5¼" (13.1 cm) long
- 14 ¼" (.6 cm) diameter, 5¾" (14.3 cm) long

1-inch (2.5 cm) nails
Wood glue

Tools

Pruning shears
Ruler
Pencil
Tack hammer

Twig Techniques

Cutting
Nailing
Gluing

1. Use the pencil to mark both of the 6½-inch (16.3 cm) front legs at 3 inches (7.5 cm), 4 inches (10 cm), and 5 inches (12.5 cm) up from the base ends. Line up three of the 5-inch (12.5 cm) twigs at the marks corresponding between the front legs and nail in place.

2. To make the chair back, mark two of the 5-inch (12.5 cm) twigs at ½ inch (1.3 cm), 1½ inches (3.8 cm), 2½ inches (6.3 cm), 3½ inches (8.8 cm), and 4½ inches (11.3 cm). Line up five of the 5¼-inch (13.1 cm) twigs at these marks and nail in place.

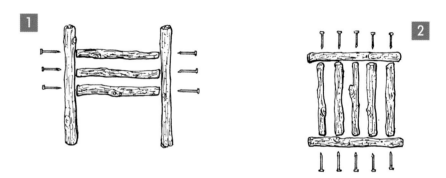

Measure and nail first the front legs and rungs (left), then the back (right).

3. Mark both 11-inch (27.5 cm) back posts at 4 inches (10 cm) and 10 inches (25 cm) up from the base. Line up the structure assembled in step 2 to the marks on the back posts and nail in place to complete the chair back.

4. Mark the 11-inch (27.5 cm) posts of the chair back at 3 inches (7.5 cm) and 5 inches (12.5 cm) up from the base. Mark the 6½-inch (16.3 cm) front legs at 3 inches (7.5 cm) and 5 inches (12.5 cm) up from the base. Line up the four remaining 5-inch (12.5 cm) twigs and nail in place to form the sides.

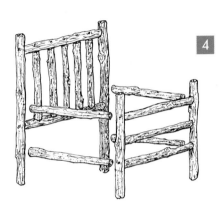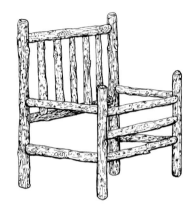

Nail the 5-inch (12.5 cm) twigs into place to join the front and back of the chair.

5. Place the remaining 5¼-inch (13.1 cm) twig adjacent to the chair back between the two top rungs. Trim to fit if needed. Nail in place.

6. Lay the 5¾-inch (14.3 cm) twigs, in the front to back position, across the top rungs to form the seat. Use as many as needed. Glue in place. Let dry.

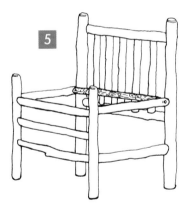

Nail the back rung in place for seat support.

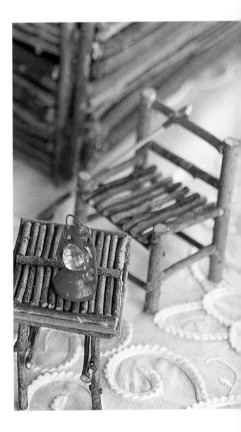

INDEX

Page references in *italics* indicate illustrations.

OTHER STOREY TITLES YOU WILL ENJOY

Nature Printing with Herbs, Fruits & Flowers, by Laura Donnelly Bethmann. Step-by-step instructions for applying paint directly to plants and flowers to press images onto stationery, journals, fabrics, walls, furniture, and more. 96 pages. Hardcover. ISBN 0-88266-929-X.

Papermaking with Plants: Creative Recipes and Projects Using Herbs, Flowers, Grasses, and Leaves, by Helen Hiebert. Plant fibers from both wild and garden plants can be used to create beautiful one-of-a-kind stationery and paper products with the easy techniques described in this book. 112 pages. Hardcover. ISBN 1-58017-087-0.

Simple Fountains for Indoors & Outdoors: 20 Step-by-Step Projects, by Dorcas Adkins. Everything readers need to know to create elegant, soothing water fountains — just like those seen in upscale catalogs, but far less expensive! Easy-to-follow instructions, step-by-step illustrations, and full-color photographs explain how to build a range of projects, from tabletop fountains to garden fountains to a small waterfall, including choosing and installing pumps and other equipment. 160 pages. Hardcover. ISBN 1-58017-190-7.

Nature Journaling: Learning to Observe and Connect with the World Around You, by Clare Walker Leslie and Charles E. Roth. An illustrated guide, with practical exercises and tips for both writing and drawing, to observing and reflecting on the world around you. Addresses urban, suburban, and rural situations. Hardcover. 192 pages. ISBN 1-58017-088-9.

Making Bits & Pieces Mosaics: Creative Projects for Home & Garden, by Marlene Hurley Marshall. Transform everyday items into one-of-a-kind works of art by adhering broken dishes, ceramics, and glass to a wide range of surfaces. With step-by-step instructions and full-color illustrations and photographs, readers can create 25 projects including mirrors, frames, clocks, vases, garden pots and urns, stepping stones, and more. 96 pages. Hardcover. ISBN 1-58017-015-3.

Making Bent Willow Furniture, by Brenda and Brian Cameron. Using the simple instructions and wide range of projects in this book, anyone can make rustic bent willow furnishings for indoors and out. Projects include a quite ladder, garden tool caddy, plant stand, hanging baskets, chair, loveseat or porch swing, and more. 144 pages. Paperback. ISBN 1-58017-048-X.

Making Bentwood Trellises, Arbors, Gates & Fences, by Jim Long. Following the step-by-step instructions in this new book by noted landscaper Jim Long, readers will learn how to collect limbs from a wide variety of native trees, then craft and install dozens of trellis, gate, arbor, and fence designs. 160 pages. Paperback. ISBN 1-58017-051-X.

Scarecrows: Making Harvest Figures and Other Yard Folks, by Felder Rushing. The only book to offer readers step-by-step instructions for creating their own scarecrows. From traditional to absolutely wild, you'll find more than 20 unique projects to decorate your home or business. 112 pages. Paperback. ISBN 1-58017-067-6.

These and other Storey books are available at your bookstore, farm store, garden center, or directly from Storey Books, Schoolhouse Road, Pownal, Vermont 05261, or by calling 1-800-441-5700. Or visit our Web site at www.storey.com.